BOBBY'S
book

EMILY HAAS DAVIDSON

as told to her by
BOB POWERS

photographs by
BRUCE DAVIDSON

BOBBY'S
book

7

SEVEN STORIES PRESS
New York

SEVEN STORIES PRESS
140 Watts Street
New York, NY 10013
sevenstories.com

LIBRARY OF CONGRESS CATALOGING-IN-PUBLICATION DATA

Davidson, Emily.
Bobby's book / Emily Davidson and Bob Powers ; photographs by Bruce Davidson. -- Seven Stories Press 1st ed.
p. cm.
ISBN 978-1-60980-448-0 (pbk.)
1. Powers, Bob--Health. 2. Substance abuse--Patients--United States--Biography. 3. Recovering addicts--United States--Biography. 4. Recovering alcoholics--United States--Biography. I. Powers, Bob. II. Title.
RC564.D378 2012
362.29092--dc23
[B]
2012025380

PHOTOGRAPHS BY BRUCE DAVIDSON
PRINTED IN THE UNITED STATES

9 8 7 6 5 4 3 2 1

for

Bruce
who opened
my eyes

Jenny and Anna
who opened
my heart

Bay and Cove
Eden and Elias
who opened
my arms

Contents

CHAPTER ONE

The Way Back

THERE WAS no way I wasn't gonna be a drug addict, no way, no way. I mean I'm drinking since I'm eight years old, my mother and them used to have parties, we used to take the shots in the bottles and sip it, sip it, get a little buzzy. Everybody in the neighborhood drank, they were the role models. There was no direction, there was no principles in people's lives, people were poor, people did the best they could, and on Fridays and Saturdays they went to the bars on the corner and rewarded themselves with a couple of six-packs of beer and a bottle of liquor.

My father used to take me to the bars on Eighth Avenue and Eighteenth Street when I was a little kid and sit me up on the stool and give me a little shot of beer. They used to have a big milk case on the floor for the little kids when they came in so they could play shuffleboard and the fathers could talk at the bar about politics, baseball, the workweek, the bullshit that they did, who worked the hardest, and drink shots of liquor with beer chasers.

It was a big deal when I used to go back to the neighborhood and the kids would say, "Where were you?" and I would say, "I was in the bar with my father." It's like going to preschool, before you become an alcoholic, they're taking you to the bar, they're showing you where the stool is, they're showing you there's a bartender, they're showing you there's cursing and yelling, you mind your own business here. When you're older you get schooled on how to go into bars. I couldn't wait till I could go into a bar, slide my little ass on a stool and sit there and have a beer, smoke a cigarette and look at everybody around the room, and nobody'd say, "Get out, kid, you're too young," or anything like that. It was such a fucking big deal, it was so cool, so cool.

My brothers drank, my sisters drank, and they all hung out in bars and they'd be partying. They worked too, but there was ten people living in the house and everybody had an individual life. I see it like a whole chess game and everybody's moving, nobody's bumping into each other because you can't or there'll be a fight. Then every once in a while there's a bump and a fight breaks out.

If my father didn't come home, my mother would be looking for him and she'd be saying, "Go get your father, go down to this bar, if he ain't there, go down to here. If he ain't there, go over there." I was like a fucking Indian scout, I had to go and get him.

My mother'd cook and make dinner the best she could, no matter what it was. She put food on the table even though she was drinking, I don't care if it was just potatoes or if it was just oatmeal. I can remember eating oatmeal for five or six or seven days in a row, for breakfast lunch and dinner, because that's what we had. She would make apple butter out of apples and icebox cake out of graham crackers with cherry juice and cream and applesauce and she called them icebox cakes. She used to make bread pudding and rice pudding.

She'd make a big roast when she had money, and everybody would eat. My aunt would come through the door and she would call my mother, "May," she would say, "May, I smell the corn beef and cabbage all the way from Bay Ridge." We would get a big kick out of that. But the one thing about my aunt is that she knew about my mother. She was the one who sponsored her to come to this country when my mother was young, when she was sixteen. She always helped my mother, she was a great person for my mother to talk to even though my mother would be in the house drinking, or getting drunk and cooking or whatever. My aunt was always there to tell her, "May, you should slow down, you should take it easy." "Stop, don't do this, don't do that." I always knew everything was okay when my aunt was in the house. She'd say, "Hiya Bobby, how are you?" When everybody was calling me "Bengie" she would call me "Bobby," and I'd say, "Oh, okay, Aunt Lilly, everything is good."

I never really did like my name Robert. They started calling me "Bengie" when I was around eight years old. One of the older guys on the block, Tommy Conroy, who hung out with my brothers, he called me Bengie like the stray dog in the movie.

I had four older brothers and three sisters, which made us eight. First came my brother Randall, then Billy, then Betty, then Sal, then Margie, then Frankie, then me and then Lillian. There were so many people living in the three-bedroom house—ten of us. It was a cold-water flat, we used to have to heat up the hot water to take baths, and we all used the same water. We had a coal stove and me and my brothers would go get oil, the fuel for the kerosene stoves to burn in the wintertime. There was no steam heat, we used to have two or three kerosene burners in all the rooms to heat up the house.

We played on the street between Nineteenth and Twentieth. It was a really busy block. People used to sit out on the stoops. They

would all come out in the summertime and be drinking coffee or beer, all kinds of people, Italian, Irish, Polish, some German families. There was an empty lot fenced in with weeds and rubble, across the street was the factory where my father used to work that made medicine cabinets and stuff like that.

On the corner was the delicatessen, Appanel's. We used to go down to the store and take a note from my mother or father. Then Mrs. Appanel would give me the stuff and write it in the book. Sometimes when I went down to the store Mrs. Appanel would say she couldn't give me anything because the bill hadn't been paid. I felt ashamed and embarrassed and would have to go home to tell my mother. She'd get mad and sometimes send me back for at least the two beers, cigarettes and bread, and she'd say: "Until Frank comes home tonight, then she'll get the money."

My mother took me to school for the first time when I was seven. Before that I was playing in the house, imaginary stuff, or going places with my mother. She used to take me when she walked my brother Frank the nine blocks to the Holy Name School where my brothers and sisters went and later graduated. One day we went up to Holy Name School and she left me with the nuns. When I got there, no way, I didn't wanna stay, I started screaming and crying but a nun pulled me into the school where I just screamed all day. It was so scary. They tried to shut me up, I kept telling them I wanted to go home. I was just very whimpery, I didn't want to be there, I wanted to be with my mother, and from that day on I never learned anything and never wanted to be there. I went through Holy Name School not learning how to read or write.

I went to school with ripped pants or maybe a hole in them and my mother would sew them or make a patch and kids would make fun of me. To go to Holy Name School you had to have a

little bit of money, and our family didn't have any. They skipped the tuition for us because we were one of the families that couldn't afford it, but being that all my brothers and sisters went there, they were letting me go there too. I was probably the worst out of all of them because every day from the time I was seven, I woke up and did not want to go to school. When I was little I was very sick, with bad asthma. It kept me out of school a lot, although my mother and I played on it too. I spent a lot of time making believe I was sick and because my mother was a drunk, if I cried enough, if I screamed enough, she would keep me home. So I was absent an awful lot. When I was in the first, second, and third grades, it was so hard and painful for me to be in school that she made excuses for me being sick.

I was such a problem at seven and eight and nine that they used to bring my brother Frank from his class down to my class to sit with me to try to help me read or write my name, write words, to help me spell, but it just didn't work. The teachers weren't very nice to me, I really didn't like them. I was hit a lot, I was punished a lot, I was put in the back of the classroom a lot. I remember wetting my pants a lot. I would raise my hand to go to the bathroom and they would say, "No, you can't go," and then I would wet my pants and I was made fun of.

I once went to school with sneakers, but you weren't allowed to go with sneakers so they made me go home. Then I went with shoes that had holes in them and that had to have cardboard in the soles so the socks wouldn't get wet or ripped. If I put my foot up and some of the kids saw the cardboard they would make fun of me, and every time somebody made fun of me, naturally I wanted to fight them or I wanted to get back at them—to get even. I was beginning to hate everybody, I was beginning to hate people.

I didn't like being off my block, I didn't like being away. I was always very frightened. Every day I went to school something happened. There were periods where nothing happened for a couple a days, but a week didn't go by without me, along with my mother, being called up to the school, or me being punished or put out of the classroom. There was always something: I hit the teachers, the brothers came down, I fought with them, they pulled my hair, they hit me with rulers, they whacked me with keys. I seemed to be such a rebel, but I just didn't know what was going on. People weren't nice to me and I couldn't figure out why. What bothered me was that I had a very hard time learning and the long walks to school seemed endless, especially in the winter.

My mom was this little tiny hundred-pound woman about five six or seven. She was very thin with curly brownish hair, sometimes permed and sometimes tied with a scarf. She was always tough with the people on the block, she cursed a lot. I was a kid so she always looked big to me. I don't look like my mother, at least I don't think so. I was told that I look like my father. My father, Frank, was a little tiny man too, hundred and twenty pounds, a rough little man from Nova Scotia. They were both, my mother and father, born in Newfoundland, one was born in St. John's and the other in Sally's Town. My mother's maiden name was Pedel and my father's name was Powers. From what I understand it used to be Power but he put an *s* at the end of it coming across the border, why I don't know. I heard my father snuck across but maybe he just walked. He was about eighteen or nineteen when he came here. They didn't know each other. I don't know exactly where they each lived before they were married, but I think they lived on Fourteenth Street and Seventh Avenue in Brooklyn. They used to have Newfoundland Night dances in the Grand Ballroom at Prospect Hall and my aunt

took my mother. I think my mother was seventeen or eighteen. That's where they met.

They were all heavy drinkers. I never knew about their courtship, I never asked. I guess I was too involved with myself to ask those questions. I wasn't brought up to say, "Ma, Dad, how did youse meet? Where did youse meet?" I found out most of this information when my mother and father were sitting in the house having these parties and all the people were over at the house drinking. My uncle Jack might have been there, my father's brother, who my father fought with for years and didn't like. Every time he came down to the house I would hear bits and pieces about where my mother came from and how she came. My aunt might tell me one little thing, but to sit down and actually say, "Ma, did you love him? Dad, was she good-looking?" I never thought to ask anything like that.

My mother was a maid. She used to do some well-to-do people's houses out in Fort Hamilton when Fort Hamilton Parkway in Brooklyn was a really classy neighborhood. My father was always a factory worker, he was a hardworking man, not educated at all, I don't know if he went to the third, fourth, or fifth grade in school. I think my mother was more read than my father, my father could read but not as well as my mother. I used to watch my mother read, she read good. My father would sit and read the paper but he wasn't really good at it, I know he wasn't good at it.

I was around eight or nine and we would have to go to the subway to meet my father before he hit the bar, because if he hit the bar that meant we weren't gonna eat and he was gonna spend all the money on some woman, or some guy was gonna take it off him. So my mother used to go up to meet him at the subway station and a lot of times my father would sneak and go to another subway station and then we would have to go from bar to bar to

look for him. But I think my mother liked that because when she
went from bar to bar she would have a beer here and a beer there.
She was a pisser, a really conniving woman who worked around a
lot of situations. A lot of the energy she had and a lot of her ways I
think I have. She was good at doing ten things at one time.

I always wanted to have money. Money was a big thing because I
never had any. The first time I stole something was when my father
came home drunk one night. I guess I was around eight or nine,
maybe ten, I remember going into the bedroom and seeing his wallet
sticking out of his pocket. I got it out of his pocket and ran out of the
house around the corner and opened it up. There was seven dollars
in it. I took the seven dollars out and ran back and put the wallet back
on the bed. I didn't try to put it back in his pocket, I put it on the bed.
I thought for the first time, "I'm doing wrong." See, my mother used
to do this, my mother used to take his money. When I think about it
now I feel really bad that I took his money because everybody took
his money. He never was able to just spend his money, that's why he
used to go hide and drink it all away. He knew when he came home
she would take everything and maybe give him a few bucks, which
humiliated him. He didn't feel like a man, that's why he sat in the
house reading his paper. My mother, even when she gave him a beer,
she'd give him a little glass at a time, it used to bother me but I could
never say anything. I always wanted to tell him, "Why the fuck do
you let her do that? Why do you let her do that to ya?"

When I stole the money and put the wallet back I knew for the
first time that I could get away with it. I felt bad when I stole my
father's money, but the minute he did something to me I used to say
to myself, "I'm fucking glad I took your money!" If he knew he might
have hit me. My parents used to get drunk, they had a belt, a "cat
with nine tails," a stick with leather on it. Although my father wasn't

a big beater there were times he got really mean and he would beat me, and then my sister and me would go underneath the bed.

At night we never had any blankets on the beds in the wintertime, my mother would throw coats over us. The oil burners kept the apartment warm. The beds where we slept had bedbugs and we used to get bitten. If I wet the bed they would scream and yell at me. There were a lot of us sleeping in the house, two or three brothers in one bed, me and my sister in another bed, my other two sisters in another bed, my mother and father in another railroad room. We all slept in these rooms together. That's what it was—just all together. It was a fucking mess is what it really was. I hated it.

It always bothered me that my mother had eight children even though I'm next to the youngest, that you would have kids and not fucking be able to take care of them. When you went up to get a meal ticket from the church rectory they would tell you, "You can't have anymore," yet they were supposed to be the ones that were taking care of the poor. So early on in my life I started this resentment—from when I was seven years old with Holy Name, the parish in Park Slope, even being a Catholic and going to Catholic school. I didn't like the priests, I didn't like God, I didn't like the nuns, I didn't like anything that the church up there stood for because they weren't nice to me. I thought if they want me to be nice to God, why couldn't they be nice to me.

They never showed me any kind of example of anything. I never had a teacher hug me, never had a nun hug me, a brother hug me, or say, "Come over here son, sit down, I understand." At least to talk to you or give you kind words. You couldn't even get a nun or them to say that anything was their fault. The brothers were ex-fighters, ex-wrestlers, and had troubled lives too, they used to fucking punch you around. I don't know who they thought they were, Miss Lynn, Miss Hubbit,

these teachers, Miss Lynch, they were terrible. They cracked your
knuckles open with a ruler if you hung your coat in the wrong spot in
the classroom or if you took too long to do something. As we walked
into the classroom for the first time, Brother LaSalle up at Holy Name
hit everybody with a three-foot-long, three-inch-wide slab of board
that was sure to cover your whole hand. That was to show you what
the year was gonna be like if you didn't pay attention. Brother LaSalle
would slam books down on his desk so hard and loud kids used to fall
off the chair they were so scared of him. He had you so paralyzed with
fear, no wonder half the people pissed in their pants in the classroom.
Once he brought some people up to the front of the room, one was a
big heavyset guy, Brother LaSalle was always making fun of him and
hitting him across his ass, making him bend over the desk and making
everybody laugh at him. I could never understand why they did these
things to people, it was fucking terrible, it really was.

Holy Name was a well-established school and still is today. At
that particular time in the fifties there wasn't a black kid in the
school, there wasn't one. They prided themselves on having smart
kids, honor roll and all that type of shit, and they really paraded the
smart kids around. I was a very troubled kid, I never did what I was
told, I was a rebel and I was thrown out of the school when I was
in the sixth grade. I had a problem one day and the principal called
my mother up and she came to the office. My mother said to the
principal, "Why do you pick on him all the time?" or something to
that effect, and then the principal put his hand on my mother and
shoved her a little bit, telling her to back up or knock it off. Then I
pushed him and told him to leave his hands off my mother. I pushed
him again and he fell on top of the desk and that's when he told me,
"You're outta here, this kid is expelled!" and they expelled me. I said,
"I fucking didn't want to go there anyway," I hated the place.

The Bomb

THE WORST times for me were the holidays when I was a little kid, not having toys on Christmas, not getting toys even from my older brothers. I would have to go out in the street the next day and all the kids were gonna say what they got for Christmas and I was gonna say, "I didn't." I was gonna have to do some kind of a diversion to not tell them what I got because it didn't compare to what they got and it made me feel terrible. I always felt less than them, it was very hard for me to deal with. I kind of hid inside myself a lot, just doing bad things.

The police would go from house to house to see who needed anything. They'd knock on the door and ask my mother, "Do you need anything, any toys for the children?" and she would say, "Yes, we need something." I would get a fire truck or something like that, but it only added to my embarrassment and my shame because a lot of the other kids on the block didn't have to do that.

They would say, "We saw the guys go in your house, what did you get from them?" and I'd say, "No nothing, we didn't take anything." I would lie about things that I had because a couple of days later I would never have to show it to them. It would be all over unless somebody got a bike. I never got a bike, I always wanted a bike. I built my own bike eventually. Actually I went out and stole stuff and I made my bike.

The one thing my mother used to let me do is steal. She would always say, "Just don't get in trouble." She used to take me with her to the A&P twelve blocks away on Prospect Avenue when I was about nine or ten. I would steal records, the 45s, and cigarettes. We would have my niece in the baby carriage, my older sister's baby, and she would be a decoy. I would stick the stuff underneath her mattress, cartons of cigarettes, some records, anything, and my mother would say, "When you're leaving the store just make sure you walk right out, go up the block and wait for me."

What I had to live up to was my brothers, meaning my four older brothers. I had to live up to their reputation in this neighborhood. It was bad, fucking bad. They were drinkers, they were fighters, they robbed, they got into a lot of trouble. By the time I was fourteen, fifteen I was already in jail, but I had to live up to their reputation, and before I was eighteen and in the bars, everybody knew me as "one of the Powers brothers." My mom would do the best she could, but she had no control over them. I mean I know that she tried to do things, she was down at the police station with me from the time I was nine or ten years old, until I was fifteen. The cops brought me home a hundred times because they knew me. The Seventy-second precinct knew the whole family. They knew my brothers, and no matter where I went in the neighborhood, they'd pick me up if something happened.

I was bad. I was a bad kid. I would break people's windows, I would steal money off of kids. I ran with a gang. It started by just hanging out, we'd be sitting on this stoop, this step by the factory, and we'd sit there for maybe a half hour and get bored and say, "Let's go to a certain block and see if we see anybody and take their money." We would go up to Ninth Avenue and Windsor Place, or Terrace Place, or Tenth Avenue, or Twenieth Street, and we would see somebody we'd describe as "not like us," maybe walk up and surround them and say, "What are you doing, you got any money on you?" They'd say, "No," we'd say, "Let me see," and it just wound up that we'd rough them up. Sometimes they gave it up and sometimes we took it. We didn't care, we just told them, "You'd better not tell your mother or anybody because you know we're gonna come and get ya." The truth is, I was always scared to fight, but would never not fight. If I had to fight, I had to fight, win or lose, but when we were with the gang, with the crew, if I was losing bad they would jump in and stop the fight.

We did a lot of hitching on cars, trucks, trolleys, and buses. It was a big thing when we were eleven and twelve to get up at six on Saturday morning and go hitching on Tenth Avenue and McDonald Avenue. "What are you doing Saturday? Let's go hitching." The buses were just coming in at that time but the trolleys were still there. We used to hook up on them and pull the electric cords to make them stop. Then the driver would have to get out and reconnect it. When we were older and lights turned red and the trucks stopped, we jumped on the back of a truck and would ride it for miles, not knowing that you could get killed or knocked out when the gasoline trucks used their airbrakes. We were wild, taunting the bus drivers, they used to stop the bus and chase us and if they caught us they'd beat the shit out of us. There were men we

couldn't stop from beating the hell out of us, but the percentage of us getting caught was very slim. Every once in a while we did get caught and got a beating, but then we knew the driver would be on that bus line again and we'd wreck the bus. We'd break the windows or throw eggs all over it, so they were better off chasing us and not catching us because then we didn't do nothing to them on Halloween. Sometimes we'd go out of the neighborhood a few blocks to see who was getting a delivery of doughnuts or bread so we could get some breakfast and a quart of milk.

My mother used to send me down to the Salvation Army on Fifth Avenue to get clothes out of the bin. She sent me down with three bucks and I had to come back with two pairs of pants, sneakers, socks, a shirt, the whole thing. They had boxes with different prices, shirts for twenty-five cents, pants fifty cents, and I would have to pick out some pants. Most times you'd never get the size you wanted. My mother would cut, hem or fix 'em. She was good at sewing things and taught me how to sew and how to cook, but I didn't really like being with my mother. She kept me home from school and I saw my mother hustle, manipulate, lie, take money from Peter to pay Paul, she had her beer, she was a provider, a survivor.

Easter Sunday when all the kids would be dressed and we'd come out of the house, once again it's another holiday that I didn't get no candy and I didn't get no new clothes, I didn't wanna come out of the house, I didn't feel a part of that. I came out in dungarees and I would tell the other kids, "What are youse doing with your clothes on, go change your clothes so we can go play, or so we can go hang out over in the lots," and they would say, "No, my mother won't let me." Some kids annoyed me, some kids made fun of me and some kids didn't. As I got tougher and ruthless less kids made fun of me. By the time I was fourteen, I wouldn't think nothing of taking a bat and just

whacking somebody across the face and splitting their whole head open if they as much as said anything about me.

Sometimes we would treat the storekeepers with respect, we'd just steal something and not curse at them. "Mitchie, don't worry about it. Relax, relax, relax." We knew that he would never leave the store; maybe run ten feet, twenty feet, but never come after us. He couldn't leave the store even if he had somebody else in there. Sometimes Mitchie would say, "I know it's you, Powers, and I'm gonna tell your mother." He and my mother were very good friends. I knew a lot of times my mother paid him for some things that I took, like potatoes that we used to cook in the vacant lots on Nineteenth street. We did become little terrorists in the neighborhood. When we were little kids all the neighbors would yell at us, "I'll tell and you'll get a whack off your mother or your father."

We had a little gang called "the Renegades" or "the Night Riders" and on Halloween we would go around to all the people who were mean to us all year long. We would do these "clothesline raids," steal all their clothes off the clothesline and rip them up. We'd break windows if they lived in the basement, or we'd throw paint. When we got to be teenagers we used to have Chester Appanel string up a dummy in the cemetery with a big knife in its hand. He used to make a full-length dummy of a man with a hat and clothes. If somebody came walking up the block in the evening or walking their dog, we'd be over on the stoop watching. Chester would be behind the bush, behind the hedges watching for us and the minute we whistled, he'd let the rope go and this dummy would come swinging down with its big knife and people would get scared to death. They used to have fits.

We used to go up on the roof of my building and as the Seventh Avenue buses came around the corner going to the bus stand

up the block, we would throw a watermelon on top of the bus. It would explode on the bus like an atomic bomb. The poor driver would jump out of the bus, the passengers would run away and we would laugh.

Another time on Halloween, we would be sitting around the corner with the dummy behind a truck. There'd be ketchup all over the face of this dummy and as the bus turned the corner we would throw it up in the bus driver's face onto the big windshield and the driver would think that he had hit a person because the dummy had a head, arms, jacket, and everything. He would actually get terrified because when the thing hit the windshield of the bus, as he came around the corner very slowly, maybe two to three miles an hour at night, all this ketchup, which he would think was blood, would be all over the window. I remember we once had a bus driver who came out of the bus and took his badge off screaming at us, almost crying one night. He says, "I ain't doing this no more, youse guys are bad!" The bus driver quit the job.

We used to sit on the stoops at night and play games. Our parents would let us out if we stayed on the stoop, if we stayed within their eyesight. Sometimes we did it, we just said, "Yeah, okay, sure." We'd sit there and we'd name cigarettes, all the different kinds of cigarettes, from all over the world. You couldn't name one twice. If you named it twice you were out, and last one out was the winner. We would do the same thing with cars, naming all the different makes of cars. And a lot of cars did come down the block, down Twentieth Street. We played a lot of Monopoly. At night we used to sit under the lampposts. There were two of them, one on Nineteenth and one on Twentieth Street. We'd sit there and we'd play Brisk and Casino. We had signals, hand signals with our partners, and we would cheat with each other.

Touching your nose and your ears were trumps. When the neighbors complained about our noise under the light, we'd have to move for a while, back to Twentieth or Nineteenth Street because we couldn't play where it was dark.

In the summer we would eat the cherries off a big cherry tree. We knew what time the cherries were coming and we'd have to sneak, like *Mission Impossible,* up on the roof so the people wouldn't throw rocks or bricks at us or chase us or hit us with a bat—all to get a handful of cherries or a peach or something off a tree. We used to jump off these two-story buildings like we were fucking Spiderman. That was our fun. We hung out, we played a lot of stickball, cards, and we developed a gang right on the block.

On the 4th of July, we would collect all the dead fireworks and make bombs out of the gunpowder. I remember making a pipe bomb with Norman, Anthony, and a whole bunch of us. This guy Norman was pretty smart, really smart. He read it out of a book and knew how to use the charcoal and the sulfate and all these chemicals to make gunpowder for the bombs. Like a little Arnold Stang he would make this shit, and he would tell us that we could do this or that. I would say, "Yeah, wow, this is good, let's make a bomb, a pipe bomb!"

Another time I was on the factory steps looking right at "the bomb." All of a sudden this thing exploded and the dirt made a big-ass hole in the cemetery, because we'd planted it over the fence and into the dirt about a foot away from the bars. We ended up making an explosion so strong that it bent the bars on the cemetery fence and boy did we run. It was in the dirt, luckily. We dug a hole and stuck it in and we didn't even know that it was the right thing to do. Me and Anthony and couple of other kids would collect a whole bunch of gunpowder from firecrackers and

we sat right on the stoop, on two little steps, and we had a pile about six inches high of gunpowder because we broke open all the firecrackers. We were gonna make something. What we did was just lit the match, thinking we were going to light a little bit of it about a foot away, but then the whole pile just flared up and Anthony got burnt. It took the skin right off his hand. He jumped up screaming and went running to his mother, "Oh, my hand!" and we were almost laughing. We didn't know what to expect but he got himself a good burn. And that wasn't the first time. One of the Olsen boys, Gregory, blew up his whole chest one time, a big hole in his chest. He almost died from fireworks.

We used to say, "Let's have a Vietnam fight!" and we would throw packs of regular inch-and-a-half firecrackers up in the air in each other's face and just keep lighting them off. About ten of us stood around in the streets, one person in each square, and you couldn't move out of your square. Whoever jumped out of their square box was "out."

From Ten to Fourteen

THERE USED to be a guy, Irving, who came around with his car, a salesman who sold you linens, coats, pants, underwear, or anything out of the back of his car. Sometimes he would come in. People would say, "Here comes the Jew, he's got the stuff." He would pull up in the car, go into each apartment, sell a lot of stuff, then you would pay him two dollars a week. He did everything on credit. I liked it because when he came around he would call us over and say, "Go get your mother, I got some nice coats" or something like that. And I'd go, "Ooh ooh ooh, coat, leather jacket!" and he'd say, "Go ahead, tell your mother you want the coat and we can do it for three dollars a week." So I would get a jacket or a winter coat. I would haunt my mother for it. One time I got a leather jacket from him. It was a bomber jacket, a leather bomber jacket. I had it about two weeks and I was playing stickball right on the block and I put it on the back of a car and then the car drove away. We didn't

know who the car belonged to and the guy kept going, we couldn't
see where and he didn't hear us. He didn't stop and I was crying,
I didn't know what to do, how to tell my mother. I knew she was
going to kill me. I just couldn't get over how stupid I was for putting
my coat on the car. I went back in the house and did she get angry.
"Goddammit, what's the matter with you! For Christ's sakes you
know you got this jacket and now I gotta pay for it and now I am
paying for something you don't even have anymore! Now what
are you going to do for the rest of the winter!"

Thanksgiving my mother would cook a dinner. There was always
somebody drunk or something happening, my brothers would
be fighting in the house. The cops came to my house all the time
because of my brothers' fighting. Or my mother fighting with my
father. We had a kitchen table to sit around but you could never
all eat together. It was a table for six people, maybe four, so you
ate in shifts. My mother put up another table in the living room
and mostly the kids ate in the living room. Or the adults would eat
in the living room and we'd eat in the kitchen. My mother would
invite people over. She was a very good cook, the turkey, the whole
thing. They'd be drinking all day, starting the night before, when the
holidays were coming. They were getting bombed worse than they
usually did. The whole Christmas season it was okay for everybody
to get drunk because it was Christmas, so from Thanksgiving on it
was a fucking disaster. On the whole block there were quite a few
drunks and drinkers. Red, upstairs in the building, he'd be fighting
with the Italians across the street and my brothers would be fight-
ing with the Mackies next door. Larry would be fighting with his
mother, it was all a fucking disaster. It was terrible.

Sitting on my stoop and watching while playing with some of
the girls and guys, if my father came down the block and he was

drunk, the kids would say, "Here comes your father, oh look at him, he's drunk!" You would know because he came around walking or staggering very slowly, to go from Nineteenth Street to the house it took him half an hour. He was that bombed. He'd bounce off every car, every wall, and I was very ashamed. Nobody would say too much to me, sometimes they knew how much it hurt. They wouldn't go, "Oh yeah your father's a drunk" because everybody on the block had somebody who drank or did something. Everybody had "skeletons in the closet." The women had all different boyfriends coming to their houses, not a boyfriend, but *boyfriends*. "That's my boyfriend!" or "That's a friend" or "That's the kid's uncle," but meanwhile the kids say, "Is that your uncle?" "My uncle who? That's not my uncle." We would lie about who was in the house; it was like a big Peyton Place. Even as kids, we knew all the shit that was going on, but we just didn't say nothing to people.

I used to go over to see Mrs. Nedemski, the greatest woman with flowers. She had a backyard that was full of plants and for some reason I was very drawn to the flowers and what she did. I learned a lot from her. As a little kid I would go into the cemetery and steal bushes for her, like azaleas or lilies. I would tell her I got them from somewhere else, and she would pay me fifty cents. Even after a funeral I would get her flowers. I would dig up big sunflowers. She had the only yard that was beautiful.

There was a yard in the back of all the buildings. Ours was on the first floor. The first floor had the yard and most times the superintendent had the yard. From the first floor you could jump out the window and jump back in. After the Petersons left we were the super for many years, which meant you got free rent or half your rent paid and you had access to the cellar and to the backyard, where I later grew marijuana. I grew string beans, tomatoes, cucumbers, peppers, peas,

all kinds of stuff. I always liked to water and watch them grow—the peppers came out nice and the tomatoes came out good—and we used a lot of it in the house. My mother would say, "No, I ain't gonna use any of that, it's got cat piss on it!" but it was good.

People would hang out their clothes in the backyards and you could go down Nineteenth Street and see some of the alleyways where they would talk to each other hanging out the windows. "Mrs. Peterson, how ya doin'?" "Mrs. Whalen, Mrs. Kennick." "Hi May!" (my mother's name was Sally but everybody called her May). They would talk back and forth, from one building right over to my mother's house looking out the window. Nobody in the neighborhood had telephones. Matter of fact, there was no TV on the whole block. The only TV was on the corner, at Rignola's. You sent notes across to people. "Here's a note, go give this to Mrs. Moore, give this to so-and-so." They'd yell out the window if they wanted to borrow two dollars or a cup of sugar, a container of milk or some butter, or they would send you with a note. I would just walk over and give them the note and I'd wait and they'd say, "Tell your mother I'm a little short this week and I don't have it." I'd go, "Okay" and go back, or they would write a little thing on the note and I would give the note back to my mother. I hated doing it, it was very embarrassing, but she made me do it. My mother would say, "But do you want this?" and she would bribe me, she'd be like, "If I get this, you can buy ice cream, go ahead, I'll get you an ice cream." If I wanted it bad enough I would go and do it. Sometimes I did but sometimes I didn't.

I was a little messenger for my mother. When she got into drinking really heavily, she would hock stuff in the hock shop, like my father's suit. How could his own wife hock his only suit? Or she would hock her wedding ring, which was a piece of gold, and she would get two or three dollars, which was enough for her to buy a six-pack. A six-pack

was a dollar and she would get some potatoes or something and come back home and make dinner. When my father would get his pay, she would go back to the hock shop, pay the three dollars and get her ring back. She used to do this every other week. It was like a secret and she would say, "Don't tell your father, don't tell your father," and I'd say, "Ma, he's gonna find out about the suit," and she'd go, "No, he don't have no reason to wear it. He's not gonna look and I'll tell him it's in the cleaners. Don't worry about that." He would look for his suit on Sunday and he would say, "Goddammit, you hocked it!" and then he would look at me and say, "You know." He knew I was in on it.

Even when she kept me home from school, if one of my brothers was coming home or coming into the house, I would have to go into the bedroom and hide under the bed so he wouldn't see me, so she wouldn't get into trouble for keeping me home from school. I did that a lot of times, I was always hiding in a closet. I didn't want to go to school but she kept me home anyways. She could have tried to teach me at home, but she didn't. My mother never taught me how to write a thing. She never had me hold a pen, she never sat down with me and said, "Here's how you spell Bobby." I went to school not even knowing how to write my own name.

All the other kids were writing and reading out of a book a little bit. They'd ask me and I'd say, "I can't, I don't know how to read." I think I'd missed a year because of my age. My birthday was September 30th but school started at the beginning of September, so I didn't go to school until they could get me in. There was no kindergarten, this was Brooklyn. There might have been a kindergarten but in our family we could have thought it was only for rich people. Anyway, I didn't go to kindergarten.

As a kid I got into so much trouble. I set the factory on fire, it had bales of papers and I just went into the back with a girl and a

couple of other guys and put a cigarette inside a book of matches near the papers. Later on it just went *poof*! This whole factory was on fire, a blazing seven-alarm fire, firemen all over the place.

When the fire started, I ran home. I looked out the window and saw all these lights and firemen but I wouldn't come out of the house during the whole fire. The block was a mess of fire engines, ambulances, people playing in the street, the firemen overcome with smoke. This factory went up in flames because it was all wooden floors, everything in there went up like a matchbook. Then the other factory across the street, later on when I was a teenager, I set that on fire too, but it was an empty factory at the time because they were building the expressway. I also liked to set off false alarms. They've disconnected a lot of the alarms now.

In the summertime my mother and them used to put me away. They'd send me away to homes because I was in so much trouble on the street with the neighbors, the cops, the gangs, and kids. They sent me to Pennsylvania or upstate, to really good homes for troubled kids. The Catholic Society or the Fresh Air Fund. One family was the Miners in Pennsylvania, Mr. and Mrs. Miner, and they had two sons a little older than me. Until I went there to live with them I didn't even know most people put two sheets on a bed. For the most part they showed me a lot of love, a lot of care, but I was still very mischievous. They had a popcorn concession stand and used to sell things at concerts and fairs. Mr. Miner worked a regular job but he had this sideline, the weekend gig. He made cotton candy at these events, and had soda and popcorn. They would have these little festivals, music things on the weekends—carnivals, county fairs. I would go with him and help him. They'd even let me help him make the cotton candy. Then I would steal some money. I would try to drink a beer in the barn,

'cause he had beers stacked up in there. It was in my head just to take them. I was in a car accident while I was there. I bit a piece of my tongue off when I went through the windshield of a car, a station wagon. We had all these popcorn seeds all over the place. My mother and them never sued or anything like that, which they should have because it fucked up my mouth.

The Miners took me to the ocean one time and I floated on a big tractor tube and kept going so far out until I couldn't see any land. They had to come out and get me because I couldn't get back, I didn't know how to swim and it was scary. I did stuff like that not knowing. But every summer my parents sent me somewhere. One time I went to a place called Bishop McDonald's Camp. I hated it. I was with all these kids and I cried every day. I was around seven or eight and I didn't want to be there. They set all the kids in one spot and gave us postcards to write home, but I didn't know how to write. I felt terrible even though one of the counselors came over to help me. I didn't want to sleep in the dorms. I did get a little bit comfortable after a day or two, but I wondered, "Why do they always send me away?" The more they sent me away, the more rebellious I got. "You're gonna do this? Fine, fuck it, I'll show ya." I thought everything they did wasn't good for me. I never had any say in the matter. They'd say, "You're going away this summer to a farm, there's gonna be cows there," and I'd say, "I don't want to go to no farm. What the fuck am I gonna do on a farm? I'm gonna miss the whole summer with everybody in Brooklyn."

I was always getting hurt. One summer I was on the back of a bike with this guy Sally and a car hit the back of the bike. My foot slipped into the spokes of the wheel and I got my whole foot tore up. I scraped all the skin off to the bone on my ankle. I had twenty, thirty, forty stitches. It was in the beginning of the summertime

and I wanted to ride on my bike but I had to sit on the stoop and put my foot up. I was lucky to have the big specialist stitch it, but the scars are still on my ankle because I went back out on the bike about a month after they took out the stitches and then the whole thing came open. I told my mother, "I'm not going back there, they're not doing no more, just leave it," I didn't give a fuck how it looked, and now it looks like skin graft all over because the skin stretched on my whole ankle. It would hurt if I got kicked there because there's only one little layer of skin, very pink scar tissue right on the ankle just below the anklebone, in the back of the foot where I had a big piece chopped out of it when the spokes all crumpled up. I was holding my neck saying, "Please help me." My foot was just dangling. I remember it dangling in midair. The guy in the car took me to the hospital and my mother came down. They let him get away. I probably could have sued and got a fortune.

From ten to fourteen years old, before we really got into the gang stuff, I was kind of lost. I was very shy, even around the girls. I always felt different than the other kids. If you see a picture of me, the broken tooth, my teeth were green because I didn't go to the dentist. We never had any money even though my father worked. People ask me do I remember when the Big Bopper, Ritchie Valens, and Buddy Holly died in the plane crash. That was a tragedy, but even something like that we blew off. Our life was a tragedy, in our four-mile neighborhood there wasn't one person that was fucking normal. Not that I could see anyway. People never told you to stop doing nothing. Take a bat and go split somebody's skull open and they'd go, "He fucking deserved that. It's a good thing you got him because I was ready to do it." You'd have to sit down and eat a body in the middle of the street to be like, "Oh, that's really crazy." Anything other than that and you were normal in the neighborhood.

Voted Most Likely to Die Before Twenty-one

MY BROTHERS and my kid sister, we had our fights. My older brothers didn't pick on me too much. They yelled and stuff like that but basically when I grew up they were almost out of the house. By the time I was fifteen, sixteen, I was very much the uncontrollable guy. There was no one telling me where I was gonna go, what I was gonna do, or how I was gonna do it.

When I was about twelve I stabbed a guy for calling me a "motherfucker." After that, anytime I got locked up it was for a violent crime like being in school with the Zip guns and the chains. I was voted "most likely to die before I was twenty-one years old." In the streets, the men in the factory and other people said to me that by the time I was sixteen I'd be in prison for the rest of my life, and by the time I was twenty-one I'd be either in jail for life, or headed to the electric chair. I was very much the little terrorist. They used to call me "James Cagney."

After they put the Prospect Expressway up here, a lot of the abandoned two-family houses had walls that would crack down the middle. I would get one or two other guys, put up big ropes and then pull the side of the house down just to watch the house collapse. It was exciting to watch it cave in, break all the windows, go in there and rob all the copper and stuff. They gave me the knickname "house wrecker."

Money was a big deal to me ever since I was a kid. I always went around looking for ways and means to make money, whether it was stealing or collecting junk. I would get some of the guys to get up with me at four o'clock in the morning, go down to the junkyard and rent a wagon. I used to sneak out of the house, just walk right out the door, tiptoe. Most of the time my family members slept because they were drinking a lot on Friday night, so you could disappear for a while and nobody would miss you.

We'd go out with this big two-wheeled wagon, a pushcart and start going door-to-door collecting the stuff people would put out on the streets and yell: "Any old rags, old junk" because that's what we heard an old man yell up in the halls. So we started doing it and they gave us kids a lot of stuff, old newspapers they'd save for us by the week. Wheeling up and down the blocks, by afternoon it was so heavy bringing it back to the junkyard. I had to find an older guy because I couldn't sign to sell what I had. I would go out and make twelve or thirteen dollars for the whole day, from four in the morning to four in the afternoon, then split it with another guy and give the guy that rented us the wagon a couple a bucks. I had a lot of money, you know, I had like six bucks, six bucks for the whole day. There were days I made twenty bucks. I can't remember making much more than that. Some days we

would steal stuff, put it underneath the rags, stuff like copper, and we would make a little more money.

We would go to Greenwood Cemetery when I was doing a lot of stealing, actually sawing the brass bars off the graves and selling them for junk. We got caught and I got arrested. But they didn't catch me with the stuff because I'd run away from it. They caught me a block away. I just said, "It ain't mine, I don't know what you're talking about," and they said, "Aw, we know you." I said, "It ain't mine." After staying up there all night sawing with a hacksaw and blades, thinking about the people that owned the graves, thinking about the dead, it would haunt me.

Always with the raggedy-ass clothes on until I was fourteen, fifteen, sixteen years old and I started working with the wagons, selling that stuff to the junkyards on Twentieth Street and Fourth Avenue. There was two junkies down there. One was 100 percent legit and the other guy, Joe, would take anything from you. He would do all the brass bars and stuff. I remember in the Ninth Street park, the big brass plates on the walls, I always wanted to take them, but I never did that. Basically we stuck with Greenwood Cemetery. We got in trouble for a lot of vandalism. Sometimes we would get really bad, nasty, like, "Yeah whatever," we'd tip over tombstones and break some of them.

When I was a kid I developed a really bad reputation with weapons. That's basically when the gang fighting started, when we were fourteen years old. By the time we were fifteen we had a gang and we were drinking. The Zip guns were a big fad. We got all the Zip gun stuff from the movies, James Dean and the Cagney movies. We learned how to make Zip guns from other people and from looking at books and magazines.

The first weapon was the bat, we always had a lot of stick-ball bats laying around. While we'd sit and play cards we'd have

things put away in a certain spot in case anybody ever came on
the block. Down in my cellar, behind the door, there were always
baseball bats, my brothers had them down there because they
were the building supers. At any given moment we could run to
the lots and gather up bats or pipes. Anything was a weapon, a
handful of rocks, anything. Much of the time we'd walk to gang
fights with half a brick in our hands. I was always very scared of
getting hurt. So scared that if you came after me I would hurt you.
I was, in my own head, this legend that wasn't supposed to get
hurt so my greatest fear was that people would find out that I did
get hurt, a number of times.

We had a car, Jackie had a car. I was about fifteen and he was
eighteen. We had a convertible, a yellow Chevy, and we would ride
around, just Jackie, me, and Junior, one of the guys that would hang
out with me. We would ride around and look at other people's cars,
watch people with their dry cleaning. They would get suits at the
tailors and put them in their car. We would follow the car and while
they did more shopping we'd bust a window and take their dry
cleaning and hock it. There used to be hock shops that would take
suits, cameras, and stuff like that. We were out every single day. If
we would pass a fruit store, even a bakery or anything like that, we
would stop, look, go in, and take a cake or something, just take it,
steal it. Sneaky. We would very seldom pay for anything, we were just
a bunch of wise guys. Sometimes the guys at the fruit stores would
yell at us, "Get out of here you sons of bitches, I'm gonna tell your
mothers," and we'd just yell, "Fuck you," be nasty to them. Some-
times we wouldn't be nasty if we liked them. We thought we'd treat
them with respect. We'd steal their stuff and not curse at them.

Me and Petey sold firecrackers when we were fourteen to six-
teen years old. We each started with twenty, thirty, forty dollars

and we made thousands. The fireworks were down in Petey's cellar and we'd be selling crates and grosses of rockets. We had the whole thing going and we made a lot of money and liked doing it. It gave me some kind of status. There's a lot of power in having money because you get some respect. When I was able to go in the bar at eighteen and throw some money down on the bar and say, "Give the bar a drink," that was cool. Just like the guys that used to walk into a bar with the coat draped over their shoulders and everybody would gather around—I knew they were somebody. I knew who they were and other people knew who they were: they were "the Man," they were "made men," the guys that did hits, the tough guys. I looked up to them. I always wanted to be a tough guy and I had a lot of respect for them.

Dottie was my first girlfriend. She was fourteen or fifteen, beautiful. There was a thing about Dottie that I liked, I liked who she was, I liked her personality. She was a very tough girl, nasty and rough, but a really good-looking blonde. I think she was Polish. A lot of the guys didn't like her. I think she was just as lost as I was. I remember us having sex, she being the first girl I had, but I don't think I told her that at the time. I told her I'd been with a whole bunch of girls because a lot of people thought that. I always thought of how nice my life was then, it felt so good being with her. I'll never forget the birthmark on the back of her leg.

We had sex in Prospect Park, up on the hill where we used to drink. She wasn't much of a drinker. We were making out one night, things just got heated up. It was like, "If you're gonna be with me, you're gonna have sex with me, what's it's gonna be?" Finally it's a force thing. You say, "I'm not gonna be with you if this doesn't happen," and before you know it, it happened. It was great, I really liked her. I don't know the reason Dottie and I broke up, I think

her mother put a lot of pressure on her not to be with me. When I broke up with her she was really sad, she wanted to kill herself. She scared me, I thought she was gonna jump off a bridge.

The older guys used to take me in the bars and let me get served. I used to love a bar called the Hilltop 'cause my brothers and sister hung out there. I loved going in there all dressed up and sitting at the bar with a beer. I don't even think I was five-five, probably about a hundred pounds and I looked about twelve or thirteen years old, well, fourteen at the most. And there I was sitting there with a beer and acting like I was a tough guy, a real tough guy. I was very well liked by the older guys, so-called rack-eteers. A lot of them were in the garbage business. They respected me for the simple fact that I was a little tough guy.

I was getting arrested and in trouble and going to jail for attempted murders. We beat a kid up in the park one time, me and Mikey, when we were seventeen, still hanging out in the candy store, still doing the gang fight thing. We went to court and the judge read off the charges. The DA read off the damage done to the kid, he had the Kneelite sign indented in his jaw from the heel of my shoe from stomping on his face. It said *Kneelite* across his face. We fractured his skull, multiple contusions, and the way they read things off in court, we were like, "Man, this guy's almost dead!" It was a gang fight, there was a lot of bats, a lot of hitting, and a lot of stuff happening, and then we split, and for some reason my name came up and I was caught and identified. Me and Mike were identified by the guy. While we were waiting to go into the court, a cop came in, looked at us in the cell and said, "'What are youse gonna do now?" and we said, "What are you talking about?" and he said, "Well the guy you beat up died." But the truth was the guy didn't die. I remember telling the cop, "Fuck you, take a hike." We got cut loose with a couple more years probation.

I spent my whole adolescence going to court and being on probation. I'm not saying there aren't good cops, but I'm still angry about some police officers. Sometimes they'd take twelve-year-old kids for a ride down to Coney Island and make them walk back. I've had cops that while I was handcuffed in a cell made sure they left me hanging three quarters of an inch off the floor on my tiptoes—just because I was a nasty little bastard, making sure that somebody didn't come to help take me down.

You put a dog in a burlap bag and you beat him up and you take him out, and he sees somebody with a stick or something, he's going to go after him. You're gonna make him mean, is what I'm saying. You're gonna make the dog mean. And that's what I think happened to me. There was nobody around to calm me down and everybody that hit me, every cop that ever hit me, every person that ever beat me up and I got hurt, I just got more vicious and more angry at anybody and everybody around me.

I was out of school at sixteen and we were ordered by the court to get a job. I got a job in a print shop in New York called the Charles B. Young Company. Jimmy worked there, Frankie worked there, Brian worked there, all the guys. We all started as messengers and we liked it. It was down on Fletcher Street by the Seaport.

I wanted to make some money so I thought of a scheme of printing up chance books. I got a logo put on it, I don't remember which logo, but you needed a logo 'cause you needed it to be a union logo. I would put that on the chances: five chances for a dollar and the winner would get a twenty-one-inch color TV. Color television had just come out so the color TV shown on there was the second prize, maybe the first prize was $1,000. I would sell all the chances and keep all the money. I would make hundreds and hundreds of dollars because I would have kids going

around to all the bars selling the chances. When they would bring back the money, if they sold ten books of chances I would give them back ten bucks and keep the rest. I was a little hustler. I even sold the chances in the bar I hung out in, knowing that there was gonna be no winner. I used to sit there and laugh with a couple of other guys who knew what I was doing.

One night I came home drunk and fell asleep on the couch. The next thing I know my brother comes in, picks me up off the couch and throws me against the wall. He starts kicking me, and fighting and punching, beating me up for being drunk, then my kid-sister Lillian gets in the middle of it. I grab a jar of jelly out of the cabinet and am gonna hit him in the head with it but she steps in the middle and I hit her right in the mouth and knock out all her front teeth. Then I pick up a fork to try to stab my brother, I'm just wild after all my sister's front teeth are knocked out.

CHAPTER FIVE

Woodstock

WE NEVER liked the heroin addicts when we were young. We
did talk to them and hang out with them, but we said we'd never
be like them. Everybody put them down. My mother used to call
them "hopheads," later on "junkies," "dope fiends." The name for
heroin was "skag," "junk," "stuff," "dugee," "horse," and "smack."
Some of the older guys in the gang were heroin addicts already.
I looked up to them and modeled myself after them but I never
thought I'd become like them.

I did think heroin addicts were the coolest people in the world.
They seemed to be able to talk good, to know what they were
doing, do crimes and get away with it. They always seemed to
have a lot of money to buy dope. I never really understood how
they did it, but they were doing schemes and scams, stealing,
robbing, hustling. It seemed like they had a lot of balls. They
never gave out dope—heroin addicts never give nothing away,

never. They had this thing called "cattle rustling" where they would go steal meat at the supermarket and these guys would come on the block in their jackets with all the meats stuffed in their coats and pants. They would have thirty, forty, fifty steaks and roasts and you'd wonder how they'd got all this out of the store. They would make a bundle of money, they would do a burglary, and then they would do a robbery. When they didn't have the money, they were out walking the streets, sweating and hustling. When they got high they would come back and talk shit to us, tell us not to do this stuff. "Don't get hooked on this shit, stick to your reefer, stick to your drinking." They would tell us to stick to certain things but sometimes people just used a little bag of dope every once in a while.

A lot of these guys died. I don't think all of the addicts died from drugs, but I think they died due to the fact that they were heroin addicts: liver disease, car accidents, murdered, died mysteriously, found dead, OD'd, wild stuff. Whole families I knew, from the mother to the baby brother to the grandson—all dead from heroin. Thing was, we would talk about it for a while and then we just moved on. Somebody died, it happened and that was a shame, but there was no awareness of what was going on—nothing ever clicked. There wasn't much grieving.

By the time I was eighteen we're hanging out in the bars, taking a lot of drugs, smoking pot, drinking. I met Pat at a park dance. Pat was Irish, as short as me, maybe an inch smaller, with dark reddish hair. She was very cute, but didn't have such a good complexion. Her father had left her mother and she was living with her mother, her little kid brothers and her uncle Gerald. I got to know her through the candy store on Thirteenth Street and we started hanging out.

Pat was from a rival gang in south Brooklyn on Eighth Street and Fourth Avenue. She used to go out with one of the guys from the rival gang, Vinny. Because they knew that I was seeing her, if I wanted to show I had balls, I had to walk Pat home every night past Ninth Street to Eighth Street, into her hallway and make sure she got upstairs. There was a few times I got caught when they were waiting for me and wanted to beat me up.

Having sex with Pat was a big thing. I'm not even sure when we first started having sex, if it took place in her house, or my mother's house, or in the park. It was a really big deal at the time, having sex with a girl. I was always scared her mother or father was gonna find out or she would get pregnant, which we didn't think too much about. Nobody was gonna go into the store and buy condoms, we just didn't do it. Some of the girls had abortions at seventeen, eighteen, nineteen years old. We were hanging out in the park, drinking, going to work, having gang fights and going to some parties.

Pat was my girlfriend but I was still seeing Dottie. Dottie was up in this neighborhood on Prospect Avenue but away from them on Fifth Avenue. She was young, fourteen, and couldn't leave the neighborhood that much. Pat was sixteen and could do more roaming and stay out later. I'd be with Dottie until nine o'clock, then go see Pat because she could stay out till ten. I'd walk Dottie in and she'd say, "Are you going home?" and I'd say, "Yeah, I'm going home," and then I would go see Pat. I always felt bad about what I did, being sneaky and all like that, but you know when you're hanging out with the guys it's a cool thing seeing two girls.

I always had these feelings for Dottie but I liked Pat too because she was a "one of the gang" girl. She could have a beer or two with us and came to most of our drinking parties, not that she was a

big drinker. So I was actually with Pat more than I was with Dottie because she could be with me more and I wanted to always have a girl on my side. From the time I was sixteen I stuck with Pat, hanging out, then breaking up, on and off, it was a crazy four years. Once Pat was so jealous she pulled a knife out and tried to stab me in the back, saying I was seeing someone else. I was seeing Dottie. Then her hand closing on the knife and me saying, "What, are you fucking crazy?" I hit her. "What are you trying to stab me for?" I know I rattled her, but I wanted to hit her for doing that.

Pat was eighteen and I was twenty when we got married. I had my son Robert Jr. "Bengie" and after a year we had our daughter Carrie. It's what everyone did. By that time we were having a lot of marital problems. I was drinking heavily and working nights. Then my wife started seeing another guy, cheating on me and going out. I followed and caught her. She did this with my sister-in-law Cathy a lot, my brother Frank's wife. They were hanging out in bars while I was working every night overtime, trying to keep the apartment and just "make it big." But my wife didn't see it like that. I was never home and though we did try to love each other, to solve our problems, something was never right. I didn't treat her nice although I tried very hard.

Pat was with her girlfriends and leaving me with the kids. I was having a hard time finding somebody to watch them while I was trying to work at the job. I was the type of guy that never took a day off but I started having to take days off because if Pat worked nights, she wouldn't come home. She was supposed to be home by one o'clock in the morning, but she was going out to bars and wouldn't come home till six or seven. By that time it was too late for me to go to work, I was supposed to be in at eight a.m. They understood it a little bit on my job. The company loved me,

I grew up with the company. I would call them and they'd punch me in and try to help me. They took me to bunny clubs when I was about eighteen. We drank and went out. I liked it, going to bars. But going home at night and not having my wife home, just a babysitter, I would take the baby from the sitter and sit up all night waiting for my wife to come home. And I would drink. I would drink myself to sleep. I was jealous, angry, and very sad about what was happening. And scared because I had kids and didn't know what to do.

My family wasn't helping me, they took the attitude, "Well, you got yourself into this, now get yourself out of it." Every once in a while I was wringing my hands: "What am I doing, who am I, where am I going?" And then I would distract myself by getting into a whole bunch of illegal shit.

One night I got a phone call. It was a female voice saying to me, "You better ask your wife whose baby she's carrying and who's Bill." Then they said she was four months pregnant. What? What the fuck is this? And I got two kids in the house. It was two or three in the morning when Pat came home with half a bag on, she had been drinking. I got her at the door and said to her, "My God, are you pregnant? Take your coat off and let me see." I remember her admitting that she was pregnant by somebody else. I didn't know what to do. When she came home and was pregnant, it blew me away. It really destroyed me. Something happened inside that sent me on a rampage of anger and resentment about women, about who I was and what I was supposed to do. My fucking life was over, I was devastated and shocked. I threw her out of the house. I knew I didn't want to be with her but I didn't know what to do with the children. I tried to get different baby-sitters, my mother, my father. I finally got a woman who would

watch them in the daytime until I came home from work. Later, the woman said to me, "Can I take the kids home and watch them at my house and you pick them up on the weekend?" I said, "Yeah, we could do that."

I never cheated on my wife—I never went out with anybody. I probably saw a prostitute on the job where I was, that was part of what I used to do. We worked twenty-four hours around the clock printing for law and financial companies. I used to get prostitutes for the big lawyers and Wall Street bosses. I knew these madams and I'd be the one to call them up to bring the girls down to the firms. I also knew women because I'd hang out in the bars on the Upper West Side and the Upper East Side. I could get what I wanted for nothing from the girls. It was a status thing. Yeah, I can have you, and I did. I was cool. I never felt good about being with a hooker, I was always a very shy guy, but I did do stuff like that.

At the bars they started to do a lot of pills and I started to do even more pills and use speed and smoke a lot of reefer. I thought, "I can make money doing this." So while I was working in the printing company I took out a loan for a thousand dollars and started dealing drugs. I bought speed, pills, pot, mescaline, and LSD and sold drugs up on the parkside, better known as "Hippie Hill" in the sixties. It was a big festival, a small Woodstock.

I became a major drug dealer. Pat used to come every once in a while and take the kids out. Then I gave them back to her. She and her boyfriend Bill had the kids for a while until I saw what they were doing. I didn't like the way Pat was treating them. I went over there one night with money to give her. We had become sort of half-assed friends. Like, "You've got your life, I've got mine, you've got the kids—here, take some money." And I'd give her some money. One night I went over there and I saw that she was

locking them in their room. Carrie was locked in her room and the latch was on the outside of the door. I said, "Why's the fucking door locked?" and she's like, "Well, you know, they come out and they bother me." "What do you mean they bother you?" and I kicked the fucking door down and took the kids away from her and brought them back to the woman who'd been watching them. I hated Pat at this time. I really hated her.

When I'm up on Hippie Hill in the park, that's my domain, that's when I became "Bengie the drug dealer." From the early sixties to 1970, I made literally like ten million dollars. People thought I had a lot of people behind me. I was dealing a lot of drugs, supplying the whole neighborhood with drugs. The cops weren't so much a presence, they seemed to keep a blind eye to what was going on. They were there but they didn't know what to do—they didn't know how to handle us. We were flying on acid.

I was also hanging out in the after-hours clubs and "skin popping" speed. I didn't mainline right away until one day John, a hairdresser who looked like Edward Scissorhands, said, "Let me try to get you off." I stuck out my arm. He shot me in the arm but he missed, he fucked up the shot. Then I really wanted to find out what it was all about. He gave me so much that it fucking overamped me and I was shaking all over. He blew the shot but he also blew my brains out.

At first you're scared, I was terrified, but then as I came down a little bit and I didn't die, I started hallucinating. It was cool, wild, and psychedelic, weird. We were with girls, we'd be naked doing all this crazy shit. You had to do it in a safe place where nobody was going to bother you, knock on the doors, where nobody was going to bust in because then you'd get your head blown and the trip would go away. I had about eight locks on the door. I'd have girls up in my house, lay them on the table, and I'd put the speed

in their belly buttons and then put the water in and mix it all up. Your whole body is saturated with speed. You're almost fucking dead, close to dead.

Then I started shooting crystal speed and I became a lunatic, staying up for days. I was still working in the printing company. I would stay up for three or four days, go to work, stay up for twenty-four hours a day. Never tired. Super energy. Working on my job, making hundreds of dollars. I had people coming to my house buying drugs. I had money stacked away, I had guns all over the place. I sold guns, Junior did hijackings, we went out and stole cars, tagged them, and went with Cathy down to the Motor Vehicles to get them registered. We knew nurses and doctors that did abortions. We had another scheme with Cathy, who was the biggest con artist I knew: we would get these pills and would say they were pills for bringing on miscarriages. I can't believe how many different illegal things we were into, anything that made money.

I became partners with my friend Ronnie. We would get rich families from Westchester or Montauk and we built up a clientele. I'm going to clubs in the city dealing speed, barbiturates, Tuinals and Seconals, we were making money. I had a drugstore that used to sell them to us. We used to threaten the guy that we'd kill him and he was so scared he'd sell us jars of thousands of pills. We went around terrorizing people. I became my own best customer and became a heroin addict as well. We ran out of speed one day, it was disappearing from the scene but I got a couple of bags of heroin and Eddie "got me off," shot me up with heroin. Meanwhile, I'm still mainlining the speed when I can get it.

One of the best drugs I ever did was heroin because it calmed me down. Using speed I was eventually gonna go out there and kill somebody or myself because you become super paranoid

on speed. I was in TriBeCa as they called it, with the vacant lofts where they were making and using speed on Chambers and Church streets. People looked like fucking zombies—skinny, eyes popping out of their skulls, skin like leather—people who were up for weeks on end. Not that I looked much better, but I always looked at people that were worse than me and said, "Wow, they're fucked up."

Meanwhile I was bad. I used to have a big handlebar mustache and a bandanna around my head, I looked like some of the black people I dealt with who used to call me "the devil with blue eyes." I got into cult stuff and fucking speed raps that would drive people nuts to the breaking point. I had this aura that said I would hurt you.

Crystal meth. I made millions of dollars on the shit. A hundred twenty-five dollars an ounce and they were cooking it. In Queens I had a guy making it with vials of chemicals. We used to call the guy "Arnold Stang." He was a little college guy, a chemist, and he was making drugs called "acid blotters." They did this stuff up in Woodstock. We rented old farmhouses because of the odor. I was really alone in this, but I always took people in as partners because I didn't want to be alone. If it wasn't Ronnie, it was Cathy, or Junior, or this one or that one.

I had bodyguards and about twenty-five guys working for me. I had four apartments in the Brooklyn area: Forty-third and Ninth Avenue, First Street and Fifth Avenue, McDonald and Avenue I, Eleventh Avenue between Prospect and Windsor Place. I would deal drugs out of all these apartments. I took care of two children, or I thought I did. The woman who had them took care of them. She potty-trained them and did everything for them. It was a very hard time in my life. When I say hard time I was actually very

lonely, but I did a lot of acid. I shot a lot of LSD, I liked to hallucinate. I took tabs of acid and would then mix it. I would cook up some heroin and then cold-shake some speed and I would mix them all together and then shoot it. I called it "frisco speedball." A big shot. It would make me totally insane. I would go into this wild hallucinogenic trip and then I would come down and I'd be speeding and then I'd be nodding. I was an insane drug user.

Even in the drug game with as much money as I had, I still went out and robbed card games. I did stickups, I did burglaries. I didn't have to, it was part of the whole ego trip. You feel better than everyone and that you can do anything. When I had a car and we were all on speed, we never got to where we were going. Our minds were so absorbed in what we were doing we'd make all the wrong turns. We'd make lefts, we'd make rights. Your mind drifts and the next thing you know you're in a different part of town. One night we tried to get to Long Island for about ten hours. We couldn't even get on the fucking Long Island Expressway.

Pat got out of New York. She moved to California with her baby, Laura. She didn't stay with Bill, he was an alcoholic and disappeared somewhere into the night, just faded out of the picture. I took Pat and Laura in. I wanted to take her back. I was making a lot of money but I'd be using and Pat really didn't like me using the needle. I had no time for her or the kids and all our lives wound up being a terrible disaster. It wasn't working. We went our separate ways.

I was still dealing drugs and going and doing all these crimes. The cars, abortion stuff, watching people die, shooting dope with people, moving their bodies to different places so the cops wouldn't catch us in the house. It was tough, very tough to do this. Looking at people and saying they died because they didn't

know how to use drugs right. Thinking that I was some kind of doctor or chemist or immortal that could do all this because of the way I mixed drugs, the way I shot drugs. People didn't like to stay and shoot drugs with me, they used to walk out of the room. Junior and Ritchie got out, so many people wanted to get away from me when I shot drugs. I'd have card games in the house and play Monopoly on speed with four or five people, our guns out on the table to be sure no one was cheating.

The kids were living with the woman but I used to take them on the weekends. One weekend I was just coming down from a speed trip after four or five days and I brought my four-year-old son Bengie up to my apartment. I didn't take Carrie because she was still a little baby. I fell asleep on the couch while he was walking around. When I woke up I couldn't find him and my door was open. I lived on the fourth floor and the roof door one flight up was open. I panicked, ran up on the roof, looked down all four sides of the roof, ran down to the street, looked around the yard, looking if I could see his little body with a white T-shirt on it, thinking the kid walked up to the roof and fell off. I looked in the house, in the bedroom, under the bed. I couldn't find my son. I said, "Fuck it. Somebody kidnapped him. One of the drug dealers came up and saw my door was open, walked in and took my kid. What am I gonna do, oh God, what am I gonna do? I can't believe this." Then I bent down on the floor and looked under the couch and there he was sleeping. He was sleeping under the couch. I pulled him out. I remember just hugging and kissing him and saying, "Oh my God, I'll never let this happen again."

But I could not stop using drugs. I could not stop using. I just kept using and using and using. It was really very frightening, I didn't know about any detoxes. I didn't know about any

treatment, I just said, "I gotta slow down, I gotta stop, this can't happen. I can't let this happen. I have children, I have children." I went around telling people about how I'm not worried about anything and meanwhile I'm always worried about everything. I just didn't know who to tell. How do you tell people you're scared or worried or anything like that? You could never do that, then you'd become vulnerable. It's like a mysterious world you're in: Kill or be killed. Be strong, just do it, be more aware, be more alert. I did a lot of speed and uppers and cocaine because the drugs kept me aware of people around me. The heroin made me nod out. I was robbed, beaten even though I would run. I would have six or seven people in my house, all with masks on bagging up the dope for two or three days. The fumes would roll off onto your skin and you'd get high. People were nodding out at the table for Christ's sake while bagging this stuff up. I would tell them they didn't have to steal, and yet I watched people steal, and other people ratted people out and then they would have to get hit—beat up—for that.

I had people working for me that robbed me and I told them they were gonna get fucking killed. Some of them left Brooklyn and got out of town because I was after them. One guy who was working for me stole from me, he lived out in Bay Ridge and one day I went to his house with a rented truck and a couple of guys. We emptied out his whole house and left his pregnant wife sitting on a kitchen chair. I took everything from him because he had to be taught a lesson. I took all his furniture and gave it to everybody on the block. I just didn't give a fuck. I said, "I'm getting my money off of this guy. He's a punk, leaves his wife to take his punishment." I'd told him I was coming and would empty his fucking house. I didn't want to do it to her, I wanted to do it to him. But

she was part of it, she knew what he was doing. She used drugs too and it was part of the fucking game. I was just meaner.

When the cops busted me, they robbed me. There were cops that robbed drug dealers, it's just the way it was. They'd rob me because I couldn't do anything, but one time I did. I went downtown, got some of my so-called "wise guy friends," and we cornered the cop in the bar. I got all my goods back, 125 guns, and I got to slap him in the face, take his off-duty revolver and say, "Now you go back and tell your sergeant." He wound up getting thrown off the force.

I got heroin from these two hit men my biker friend, Chuch, hooked me up with, crazy guys who used to scare the shit out of me every time. Sometimes I did pickups for them. They would call, tell me to go to a certain bar in Manhattan by the Brooklyn Bridge. I would go like a secret agent, I always kept a jacket on so you couldn't see my tattoos. I combed my hair and looked different than I normally did. I grew a beard, I shaved off the beard. I grew a mustache, I shaved it off. I gained weight, lost weight. You took precautions.

I was told to put two nickels, a penny, a quarter, and a dollar bill on the bar and ask for a beer. The bartender would know who I was and he'd give me the key to a car. He'd say, "It's a Chevy, it's on such-and-such block and this is the license plate number." I would drink the beer, walk out and get in the car without searching or looking, drive over the Brooklyn Bridge to a certain place, leave it, put the key under the mat and go home. Then I would wait for a phone call.

I would never look back. You never knew who was looking at you, who was watching. They tested you. Might be an empty car, might even be nothing in the car. They just wanted to see if you

were going to do as told. I would get paid a thousand bucks to drive the car, but then I would get a kilo of dope to deal or sell. That's like a million dollars for Christ sake. I always paid them back because I knew they would kill me dead in a minute. I would never let anybody around this heroin, I kept it so secret. I would jump in a cab and take some to my mother's house, some over here, some over there. Hide it. In one night I would put this stuff in six different places where I couldn't get caught. In other words if you took an ounce off me, that was okay, you weren't getting the rest.

The two hit men who were giving me heroin to sell were found wrapped up in a van out in Brooklyn with a lot of bullets in them. Then I was told to get the hell out of Brooklyn for a while, so I says, "I better get the fuck out of here." I don't know who was killing who or what it was all about. I found out later that one guy got high on coke and was fucking around with the wise guy's niece and raped her in an after-hours club. That was the end of the hit men.

I had gotten fired from my job for not showing up and had marriage problems and two little children. I rented a U-Haul and I had a phony driver's license. So we're going to Woodstock, it's 1969, I got fifteen or sixteen people in the van with the strobe light spinning and I'm ringing this siren because the roads were blocked. I ran off an embankment and the van turned over and we all crawled out. I left the van 'cause it was never in my name, it was always in somebody else's name. I took my knapsack with all my drugs in it and what did I do? I shot speed, did LSD, and smoked reefer all through Woodstock. I got up in the front, saw Hendrix and a few other people. The rest of it is a blur, a muddy blur watching the naked girls in the mud. Woodstock was "free love" and "flower children," but the place stunk. We were drinking out of fifty-five-gallon drums filled with water. There was no

food for 400,000 people, the stores were empty. The farmers were giving us peanut butter sandwiches. It was crazy but nobody was fighting, not a single fistfight.

We went over to this kid Vito's house in Monticello, he worked in the printing company where I worked and his parents owned a house up there. He had a whole bunch of girls there and I gave them all Tuinals and Nembutals and they all got wacky on three-grain Tuinals, better known as "gorilla biscuits." They all started getting foolish and fucked up and then the lamp fell over and started a fire. The whole house burned down 'cause everybody was on barbiturates, meaning Tuinals, Seconals, and Nembutals. Vito was crying so much, all that was left was a screen door. I borrowed a guy's car and drove down the hill to go get some stuff, there was five of us in this convertible. I remember hitting speeds about seventy miles an hour, then making a turn and the car hit the side of an embankment and the wheels and the axle busted on the car as we went off the road. I told the guy, "Don't worry about it, I'll pay ya." I gave him a few hundred dollars and walked away from the car. I just went, "Shut up, don't worry about it." I never saw the guy again.

CHAPTER SIX

Cocaine

AFTER PAT and before Michelle there were four or five different girls. I never lived with anybody for any length of time. I didn't trust people to live with me. When I dressed up, I was really dressed good and went out to the clubs. In the wintertime I would go out in a big beige cashmere overcoat with the hat. I dressed up playing the part of the pimp, the drug dealer, the whole fucking thing.

One time I was with a girl Pam, who was seventeen years old. She was from Avenue X down Coney Island Avenue, a short little Jewish girl with long brown hair who became a really good friend. She hung out up on the parkside, this "nice little Jewish girl," who was attracted to this little wacko man. The funniest part about this is I went out with her for two years and never had sex with her. We never had sex. She hung out with me; I was like her idol or something and she just liked being with me. I could never do anything wrong.

51

She was a very smart girl. Her father had his own band and used to play in the Carlyle and the big hotels but she didn't get along with him. She'd tell me she didn't like me when I'd get beastie and angry. "I'm really getting scared and I don't like the way you're acting. I'm gonna go home." And she would leave. I'd think, what's the fucking problem, oh, fuck that. Then I would think, I know, I scared her, I scared her. I would feel bad that I scared her but I was in a scary business. I was doing scary things and she so wanted to tag along. Sometimes I couldn't have her there because I was scared. I can't watch over a girl like that all by myself. It was very hard.

Pam was always good to me, watching me, saying, "Take it easy. Don't do this, don't do that, you're going to get in trouble." And I'd to say to her, "Yeah, yeah, yeah. Shut up." I didn't treat her good at all. She once bought us tickets to *Hair* but we had a big fight and I took someone else. Then she disappeared and I didn't see her. A year or so went by. I think she went to college or met some other guy. She really had to get away from me because I was getting bad. And she did. But just like Dottie, she was always on my mind.

Later I met a light-skinned black girl named Ray. I wasn't no kid at the time. She was twenty-two years old and I was in my late twenties. I was still going to the afterhours clubs selling drugs and dealing. Actually, where I met her could have been at a club. Ray used to model children's clothes for Sears & Roebuck's catalog and she showed me all her pictures with the little tiny pink dresses, pigtails, and school clothes. She was such a little tiny thing so when she dressed up like that she looked nine or ten. Meanwhile she was twenty-two years old.

I guess it's an attraction type of thing, the gangster, tough guy. Oh, he's the leader, or he's whoever the fuck they thought I was. I didn't know who I was. There's a lot of tough guys, tougher than

me. There was a lot of guys that did a lot of things, but each and every one of us had a special territory or a special thing that we did, and we didn't buck anybody else. She probably thought I was a really nice-looking guy but I think they really were attracted to me because I had money, drugs, whatever, or I was a little crazy. But not for being a nice-looking guy.

She rarely did drugs. It was amazing. One time she did some speed with me and after she did it she says, "Never again." I was sure she was fucked up, because when people take drugs for the first time you can control them. I'd say, "Sit down, you're going to be okay. Sit. Stay." And you're so fucked up you do every single thing I tell you to do. There were quite a few women like that who came to my house or came out with me and did drugs and just went way overboard with the amount of drugs they thought they could do.

She was another one that loved me. I did have a very good relationship with her and I liked her. I used to take her to the clubs, sit her at a table and let everybody know that she was with me. I'd say, "Listen, I'm gonna go out, I gotta do something. I'll be back in an hour." She knew how to take care of herself and knew when I came back not to be sitting with anybody because that would fuck me up. We were cool. We'd go over to the park and make love, we'd go to my apartment and make love and fill up the tub with bubbles and do some acid and get high. She never did a lot, I did a lot. She would do a speck, because she never really liked getting wacked out. During two years she only got high with me about six or seven times. She liked going out, naturally enough. The women I was with, I used to buy clothes and give them a lot of money. What do you need? Fifty dollars? A hundred dollars? I would give shit away.

Then one day I go to pick her up. She lived on Eighteenth Street between Seventh and Eighth avenues in an apartment down

by my mother's house in the old Brooklyn neighborhood. She moved! And I never saw her since. She disappeared right out of my life. The landlord didn't know where she went. I couldn't find out where she moved. I tried to find out for six or seven months. I don't even know her last name. All I know is she's Ray. She was a beautiful black girl I was very much attracted to and still have a lot of feelings for. I had a picture of her but I can't find it. When she saw me getting crazier, she just disappeared. I thought later on, why wouldn't she get the fuck away from me? I was crazy! Why would you want to be in an apartment with me on acid, me talking crazy shit. You gotta get scared. What amazes me is she just wiped herself off the face of the earth. Not that I put out detectives to find her.

I was very sad when she left. It's amazing but I have these feelings for people who were nice to me. When I think about leaving Dottie I get sad. I think about some of the girls I passed up in my life and I would love to be in a room hanging out and just talking to them now that they are women, telling them what they meant to me. I could never say I was proud to be with them or I really felt good walking down the block with them or you always were very nice to me and you're one of the people that just kept up my esteem. All these women did this for me at one point or another. I could never say it at the time, I was too nuts.

After I got separated from my wife, I was hanging out with Junior's wife Cathy R. and all them at her house, and in the bars. I started mixing speed and acid. I was a real drug mixer. Bennies was speed, uppers, and we were getting these bennies in the drug store. You go down and buy hundreds of them for nothing at that time, a couple of bucks. It wasn't illegal. We knew guys that sold them over the counter. They made a fortune.

Sometimes we'd take gorilla biscuits—they make you nuts, slug-gish, out of it, totally. You couldn't do that and be a good dealer or a drug addict because you'd get ripped off all the time. I'd seen guys take these things and die right on the beach at Coney Island. The sun would bake them. They'd be there for a day or two and some-body would say, "Hey, wasn't that fucking guy there yesterday?" People would die. Just go out like a light. Can you imagine ninety degrees, somebody coming over and putting a blanket on you because of the sun? Meanwhile you're dead. You're dead under the fucking blanket. And on the beach everybody thinks you're sleep-ing, they can think you're sleeping for two days! They really could! Until the machines come around and they say, "Hey, this fucking guy was here yesterday." He's dead. People don't take gorilla biscuits to die. They take one, then two, and if they don't get high in half an hour they take two more. They won't wait.

Other times we'd take pills and stay up on Friday night right up until Monday getting high and then go to work. There were times when I was shooting speed where I stayed up for thirty days, totally and completely buzzed out. I would shoot speed in what we called "speedtrific." I would fill up six or seven sets of works, needles, and put them all lined up on a towel. It was the only thing that was in my refrigerator. I would cold shake all the speed, meaning that I put in a little water, powder, crystal, shake it up, make it all liquid, then draw it up into the sets of works. Sometimes I'd have ten sets of works laying out in the refrigerator and one at a time, in a matter of an hour and a half, I would shoot every one of them in my arm, inject it into my vein. One after the other.

Sometimes when we broke open the Tuinals and mixed the powder it would clog up the works. I see myself going nuts in apart-ments. I would be shooting dope and the works would clog up.

Photographs
Bruce Davidson
Summer 1959

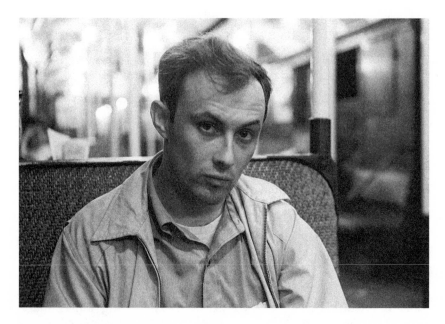

Bruce on the F train, 1959

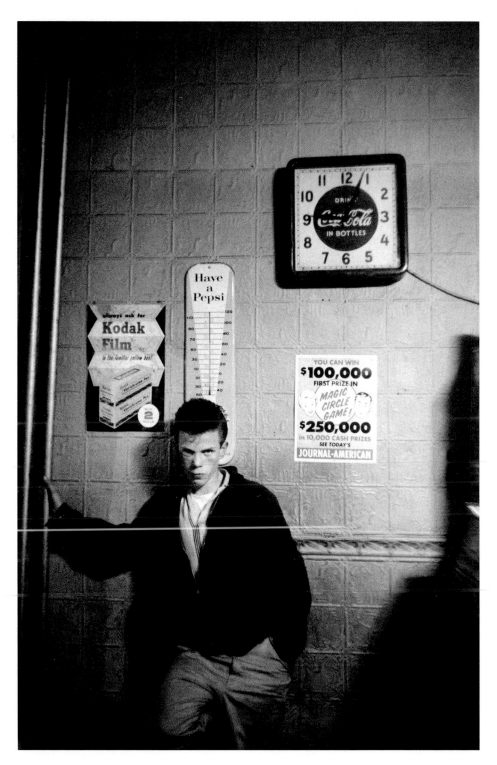

Bengie at Helen's candy store on Seventeenth Street and Eighth Avenue, Brooklyn

From a rooftop on Seventeenth Street between Eighth and Ninth avenues, Brooklyn

View from Seventeenth Street

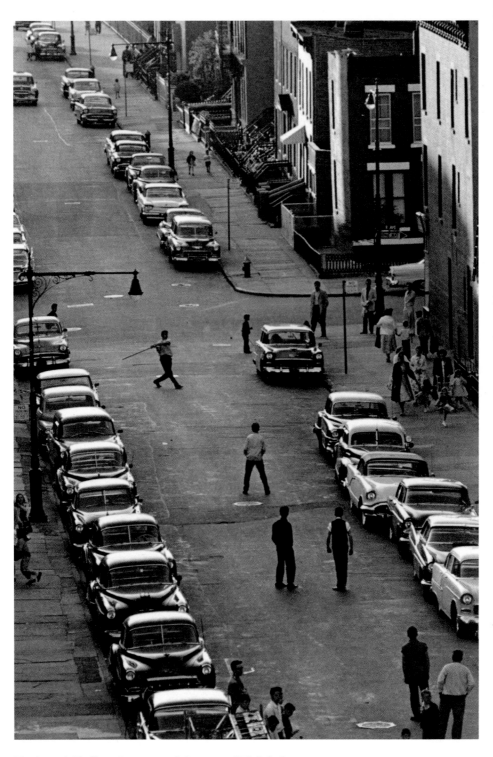

Playing stickball on Seventeenth Street and Eighth Avenue

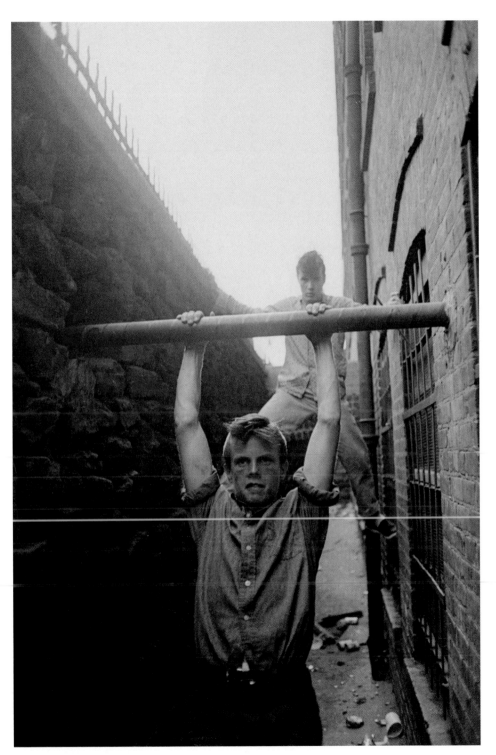

Bengie in "the hole" at Eighteenth Street and Eighth Avenue

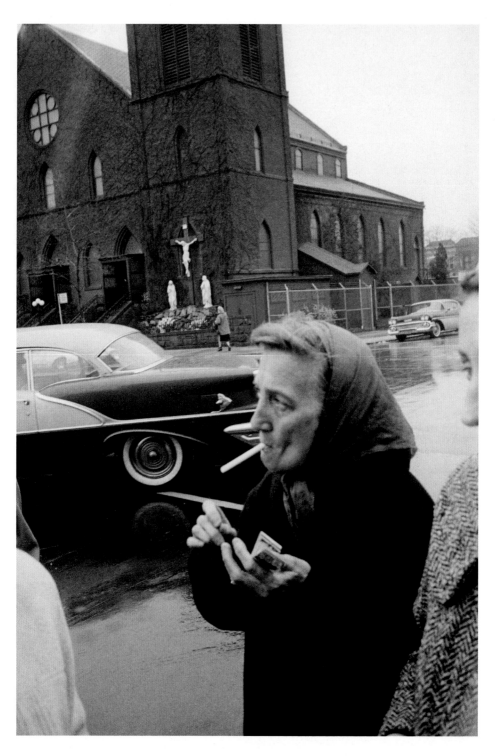

Bengie's mother, Mary "May," across from Holy Name church on Prospect Avenue

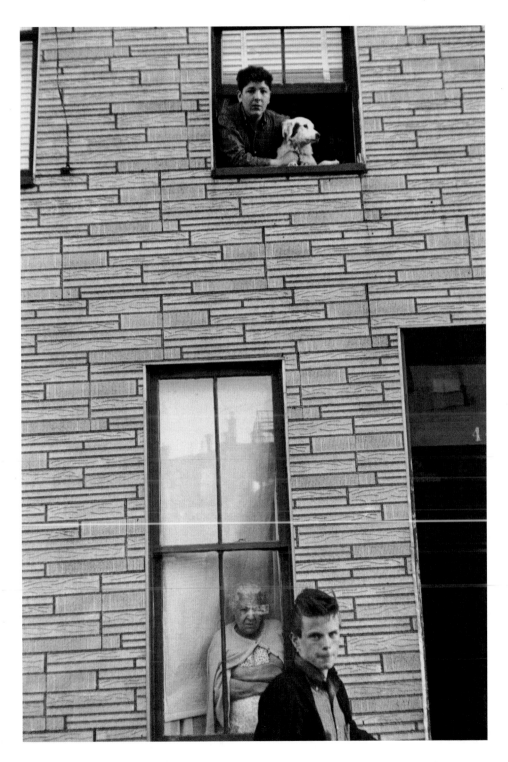

Bengie in front of friend Petey's house

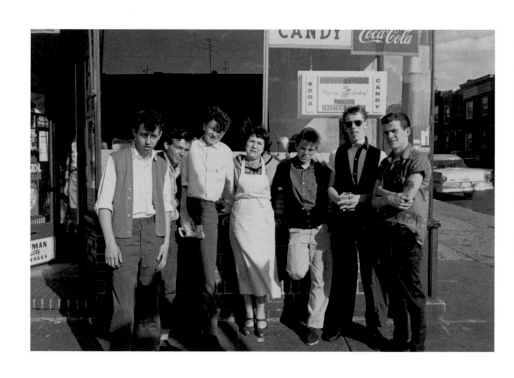

Bengie and his friends in front of Helen's candy store
Left to right: Jimmy, Hoppy, Joey, Helen, Bengie, DD, Henry

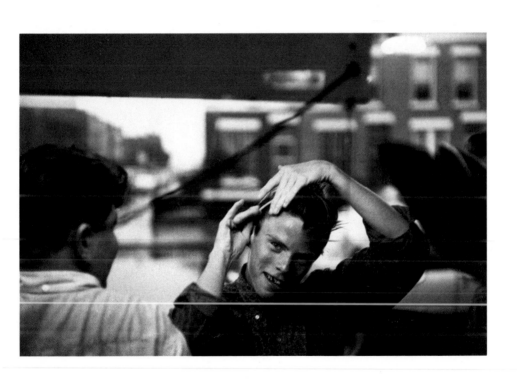

Bengie combing his hair outside the candy store

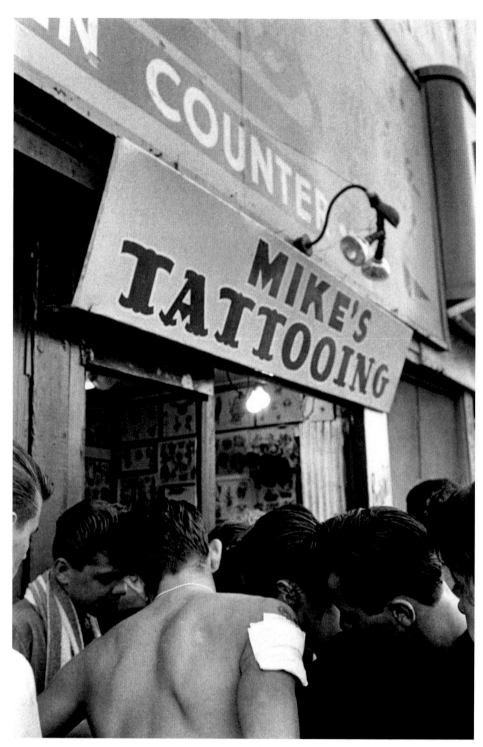

Outside Mike's tattoo shop in Coney Island

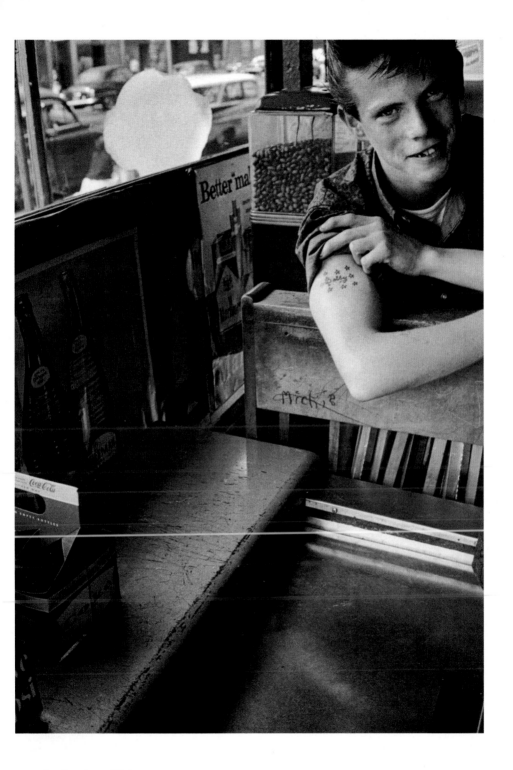

Bengie showing off his tattoo

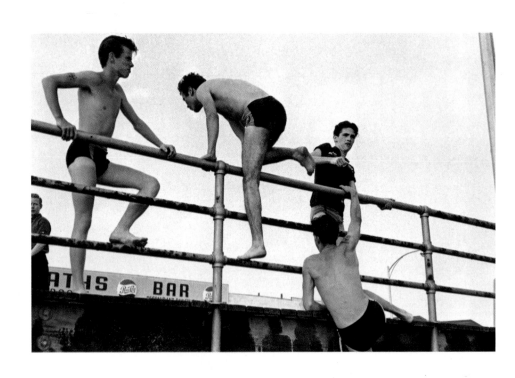

Bengie and friends at Bay Twenty-two, Coney Island
Clockwise from left: Bengie, Junior, Bryan, Lefty

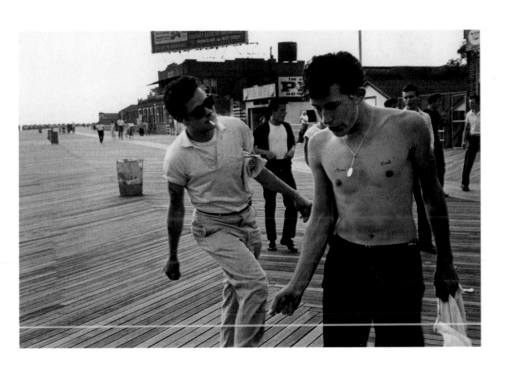

On the boardwalk at West Thirty-third Street, Coney Island
Left to right: Junior, Bengie, Lefty

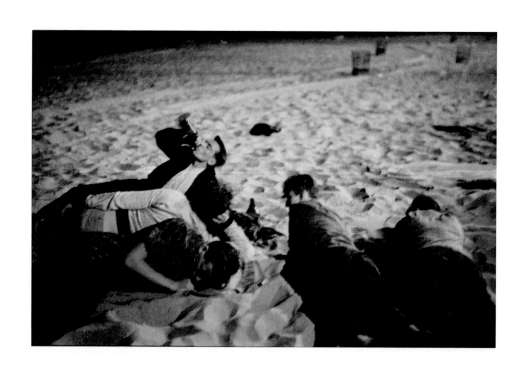

On the beach at Coney Island

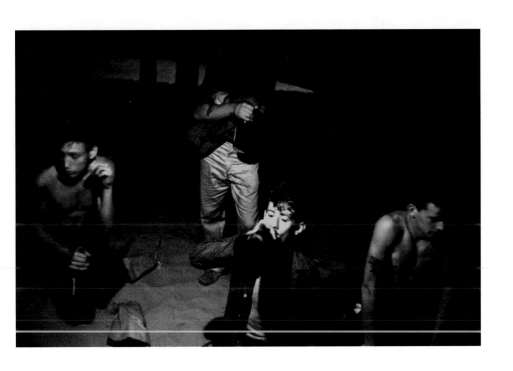

Under the boardwalk at Bay Twenty-two
Left to right: Norman, Junior, Willie, Henry

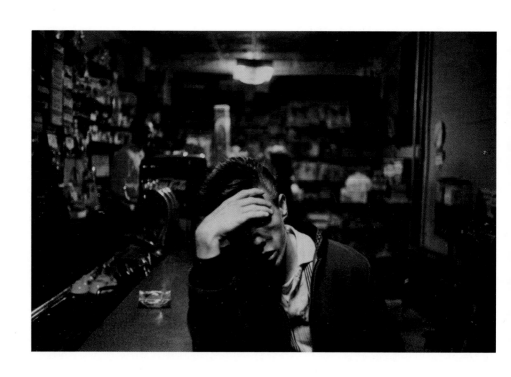

Bengie inside the candy store

I'd rip somebody's air conditioner cord out of the wall and cut the cord to get a little piece of copper wire to clean the needle out and they'd say, "Oh, what is my mother going to do about the air conditioner?" "Fuck the air conditioner! I don't need the air conditioner. I need this fucking needle unclogged, that's what I need. Shut up." I'd pull wires down from the ceiling, I didn't care. You got a vacuum cleaner? You got a hair dryer?

I would shoot speed and acid and dope all at the same time. Cook them all up, make frisco speedballs. I could do ten, fifteen tabs of LSD, one at a time for an hour. Every ten minutes I would do another tab of acid. One night I did this with a girl and we ate twenty-seven or twenty-eight Strawberry Fields each. "For every one you eat, I'll eat two." It was a game. You played these silly fucking games, like some big shot. One time I was making love and all of a sudden the girl turned into this big pile of fucking seaweed. She got so ugly I freaked out. Another time, my friend Eddie drove this girl Carol nuts for days. She woke up in the corner of the room sucking her thumb. I couldn't figure it out. Your mind is gone.

I used drugs like a psychopath. The backs of my arms used to get so sore that I couldn't lay them on the counter. I couldn't sleep at night because the sheets would hurt them. There were so many needle marks going up and down my arms. I'd lose twenty pounds. Then I would go to the steam baths and take vitamin E to make them better and lift weights. I was nuts, lifting weights. But I would get better and put on ten pounds. Then a month later you'd see me and go, "What the fuck happened to you?" I just loved it. I loved it. I loved shooting stuff and going to the edge. I used to sit on the floor of the bathroom by myself and shoot half an ounce. Then I'd put my feet near the door and just sit there and be in Oz for the night. Or I'd sit in the bathtub with a girl, naked, and just shoot cocaine and dream.

That kind of stuff went on for a couple of years. We spent a lot of time going to the Electric Circus on St. Mark's Place where I used to get high and slide down the cable off the balcony. There was sex upstairs and sex over here and sex over there, sex with guys, sex with girls—it was just what everybody was doing, wasn't nothing bad about it, wasn't nothing freaky about it. If you weren't high enough, if you weren't fucked up enough, you couldn't come in. To go into the club you had to be whacked because everybody in there was whacked. The music wouldn't stop and everybody would dance for days.

We went on like that until around 1969 when the speed ran out and I came in touch with heroin. Eddie was a genius guy who drank twelve cups of coffee a day and never worked, a drug freak who had connections. Eddie gave me some heroin with Cathy. They were doing it and he said, "Do you wanna do some?" I says, "All right, let me get a hit." So they shot me up with some dope and I threw up my guts. I started doing dope for a little while and went back to the speed; the dope, the speed, the dope, the speed. But once I started doing heroin, I started calming down. I got into a whole different world of drug dealing. It became more treacherous, more people died. People weren't dying so much in the psychedelic days. If they did, they froze to death in the winter, getting high and being left out in the cold. Well, people would kill themselves on acid trips jumping out a window here and there, jumping in front of a truck, but I never heard of anybody OD'ing, not like with heroin. Some people died from speed, they blew their hearts apart. Too much coke just blew their fucking heads off and they would die. I always played a game. How much could I put in the cooker and not die.

One time on Eleventh Avenue I put so much cocaine in the cooker that I was crazy. I ran around the house making a set of

works from a set that was from when the doctor gives you vita-
mins. There was a syringe that was wide as a nickel and I had a
nipple from a baby's bottle that was the "pacifier." I cut it with a
knife and put the pacifier over the top of the syringe. I had a big
2.5-inch-long coke spike, a long needle that was a big fat piece of
stainless steel. I put about an eighth of an ounce of coke in a spoon,
added a whole bunch of water, and drew it up into the syringe.

Eddie, Brian, and a few other guys were there. I don't know if
there were any girls there that night. I was doing this because I
was so fucking mad. There was some stuff missing and nobody
would fess up to it. There was a lot of money lying around the
house; thousands of dollars lying on the table in a box. I tied up
the wrist of my left hand; I was getting off on my left wrist. I put
the needle with this big spike into my wrist and when I went to
squeeze the pacifier, which was the bubble—we called it Bobo—
as I squeezed this thing thinking a little bit would go in, but it
was so big that it all went up in my arm. I freaked out and pulled
the whole thing out and threw it at the wall. All this blood came
down the wall and all this shit went into my body and I couldn't
do anything. I overamped. I flipped over backwards in the chair,
bit the bottom of my lip and my tongue. There was blood coming
out of my ears, my nose, my eyes, and my ass. There was blood
coming from all over. My friend Eddy put a pillow underneath my
head and tried to revive me with some cold water, but he couldn't
do anything but stay with me and hold onto the money in the
box. If I was dead I was just going to be left there and they were
going to leave me in the apartment with the door open. But about
twenty minutes or half an hour into this I came to. When I came
out of it I looked up at everybody and I said, "Wow, I can see right
through my hands." I was looking at all the veins in my arms and

my hands. I was seeing everybody as skeletons. I could see every-
thing moving in their bodies. I was on such a fucking trip from
the coke that it blew me away. When I got up I saw that all of them
shot the rest of the dope while I was lying on the floor, breathing
so lightly I was almost dead. But when you do heroin everybody is
out for themselves and themselves only. I went on to get high like
that for another fourteen or fifteen years.

When I got into the heroin the first time, I OD'd and almost
went out. Heroin took all your troubles away. So did coke and
so did speed and stuff like that, but when you got into heroin
it turned you into a bum, into a derelict. It turned you into the
person you don't want to be, into a beast because it makes you
rob anybody and everybody around you and there's nothing you
can do about it. You want to be in outer space. You want to be
where all responsibilities in your life are relinquished. You don't
have any when you're on heroin. You can be waiting to go to the
electric chair, okay, and not be worried. If the living room was on
fire and you were getting off on some dope, the fire would have
to wait till you got off. I see myself on the Lower East Side getting
high in the back of the lots and some people saying, "The cops are
coming" before I got the hit. I pulled the needle out of the main
vein of my arm and skin popped it directly into the muscle of my
arm before the cops came into the yard. This way if I got caught
and went to jail, at least I was high for that day.

Chuch

I MET this guy named Chuch through Cathy down on Homecrest
and we became friends. He was a drug dealer too and had a
lot of connections. He was this little blond-headed guy with a
square hairdo, looked like the little fucking Dutch boy on the
Dutch Boy paint can. He was a biker and had a Harley named
Cherish that we would take to bike shows. In the early sixties
when I met him, he knew these wise guys, gangsters, and they
knew him. At first I was dealing drugs with Chuch, buying stuff
from him all the time and he was buying different stuff from
me and we became really good friends and then became drug
dealers together. We would go partners on a lot of stuff. At this
time we got into heroin. They actually gave us ounces of heroin
to sell because they didn't know what to do with it. Meantime,
I was shooting a lot of cocaine so I was a little on the nutsy
side, doing coke and selling heroin. I never sold heroin before. I

sold LSD, reefer, speed, all kinds of pills and psychedelics, and everything like that, but I never got into selling heroin because that was taboo. It was a bad thing.

So me and Chuch got this heroin and Chuch says to me, "Can you sell this stuff?" That's how the conversation started, and I said, "Yeah no problem, I could do that," which I never had done before. I never cut heroin, didn't know how to cut it or anything about it. I bagged up the heroin one night and put it out on the Parkside and before I knew it people were OD'ing all over the place. I don't know if they were dying, but the word got out, "Oh, people died on this dope, it's good powerful stuff, let's go get it." Then I found out that you had to cut this stuff. You needed screens and nylons and wire hangers. I learned how to do the lab work asking and watching other people how to cut it, to get it all down pat. Take the lactose or bonita or some quinine and vitamin K, add the heroin on the nylon, mix it together screened through the nylon several times until it is totally mixed. I needed to learn how to make four ounces from two ounces, adding stuff to it, what they call cutting it to knock down the potency so people wouldn't OD.

What I did was put out a product that everybody loved. They wanted it especially when they found out people were dying. Heroin addicts are like that. They could watch somebody die and then say, "Where did he cop it?" That's what they do. "All right, so what he died ... where did he buy it?" That's the truth, that's what they say, so we learned how to cut this heroin, me and Chuch, and I started bagging it up. Chuch was selling it to me. I was still my own man and made literally millions of dollars. I became a big heroin dealer.

That's when things got really hot with the cops in the neighborhood, up on Ninth Avenue and on the Parkside and in the bars. They didn't bother me before that, but it got worse when they

found out heroin was in the neighborhood. They could deal with all the psychedelics, they could deal with the cocaine because they were doing most of that shit themselves. They could deal with acid, they were doing that and reefer, and drinking, even taking barbiturates and pills and all that other happy horse-shit, but the minute you put heroin anywhere, you become the fucking bad guy. You become the number one killer. They don't want you in the neighborhood. "Look what you're doing to our kids." Meanwhile everybody's all fucked up already.

I think that if they didn't put heroin in the neighborhood everybody would have been crazy. It calmed a lot of people down. Everybody was going to die on acid, jumping off fucking roofs doing all these psychedelics, doing drugs that they didn't even know, robbing drug stores. I robbed a drug store one time. We had all these drugs and I shot this stuff, sulphate, that we used to cut with other drugs and I went fucking blind. I had all these pins and needles in my arm and in my head. I used to do crazy shit like that and I always sold speed even though I was into heroin. I kept selling speed and using it, but then the more and more I sold heroin, the more I got into it. This is when I started selling it in the city to the doctors, prominent people, rock n' roll groups, all these different people bought this shit, and I got a big reputation as a pretty big dope dealer. It got so bad that I really didn't like it. I was scared a lot of the time.

Selling the heroin got me mixed up with different types of people who had no regard for life, people who didn't care if they killed people. This was the scary part of my life. When you're dealing in the psychotropics like LSD, reefer, cocaine, acid, Mescaline and even some of the other things I dealt in, people were normally nice, flower people. I went to many homes selling twenty pounds of reefer and all the women would be sitting

around. We'd all be smoking and doing lines of coke; everything was pretty cool in those settings at that time.

It was so different than being in a room with twenty people who were using heroin. They were fucking sitting there with guns looking at you, notorious, waiting for you to fuck up. I'm talking about the dealers, the people who were behind it, these people don't care. It's a big product, it's expensive, there's a lot of money involved.

In the early sixties when I was selling speed, there were people who became rats and were found cut up and put in trunks. I was dealing with these people from downtown. Everything revolved around thousands of dollars. People got killed for very little. Life had very little value; money had all the value. People were shot, people were murdered. They'd give them a hot shot; put some sulfuric acid in it, some battery acid in it, and some rat poison—just kill them. People did crazy shit like that when they didn't like someone. It was a very scary time meeting Chuch and becoming friends with him and then starting to hang out all night, selling the drugs and then starting to use heroin.

Chuch was a barbiturate-head, he would take a lotta lotta pills. It slows you down. I can remember him taking forty Tuinals. He had this 1948 truck, a van with flames painted on it that he used to transport his bike in. I remember him being stoned and driving that thing all over the place. The more stoned he got, the better he drove. You would think he was gonna crash, but he didn't. It was the wildest thing I ever saw in my life, the way Chuch handled a lot of shit while being high on the pills. If you took barbiturates early in the evening and then drank and later shot up some heroin, you very likely could OD like Paulie, Sal, and a few of the other guys. So Chuch was that type of guy, he would do all these drugs.

In 1970 we were doing drugs and making drug deals. We used to sell a lot of drugs to people, but I never sold drugs to anybody I didn't know or didn't trust. I had to know them pretty well, especially a heroin deal because you can get caught and go to prison forever. Chuch sold some drugs to a guy who wanted two ounces of heroin, so we sold him the two ounces of heroin. But not good heroin. Then the guy came back and he said that it was so good he wanted four more. I said, "Chuch, this guy's no good, this guy's a fucking cop or a rat. I just sold him shit, stuff that I know is no good," so I told Chuch not to sell to him, but Chuch sold it to him anyway. I stayed out of the whole deal, because I didn't like it right from the get go. There was a guy involved, Charlie, Georgie, or something like that, who was just no fucking good. I didn't like the guy anyway; I never liked doing any business with him. I don't like guys that are strung out, fucked up, looking for money; he looked like he would be a rat bastard, a shady hustler. I can't deal with people like that. He was tall, thin, skinny face, bald on top with a rim of blondish brown hair. I deal with calm, collected, business people. They might be even a little notorious and shit like that, but they're making sense, you know what they're saying, "We're gonna meet, we're gonna buy this, we're gonna do that, and this is where we're gonna do it." They make a little bit on the deal, I make a little bit on the deal, they make a little bit more, I make a little bit more, I compromise, they compromise, and somehow or another we get to a happy medium where we both can do our thing and then we do it boom, boom, boom, it's done, you're happy, I'm happy, good night, see ya . . . that's the way it was done. And I always dealt with people I knew for years and years and years. I didn't know this guy . . . so what happens is the house gets raided the next time. The guy was a rat.

There was a drug bust at Chuch's house. When they heard all the commotion outside, everyone who could jumped out a window but Chuch and another person got caught in his house. The guy who he'd sold the drugs to pointed him out and Chuch got busted, which meant that he could go up for ten or twenty years. We had a great lawyer at the time, a very notorious lawyer. He was my lawyer for years after that and got me off of attempted murder and drug raps where I was facing seventy-five years. Anyway, Chuch got caught. He was going to court and we were telling him, "Don't worry, you're gonna beat it; you're gonna beat this, you only got one drug charge." But it came down to he might have to go away for a year, and he wasn't the type of guy that could go away.

Chuch was terrified of going to jail—he just wasn't a jailhouse guy. He was one of the original flower children. He didn't even have fights with people. He played nice, he was a real good talker, he wasn't a hitter or a gang guy, which is what attracted me to him. I don't think I ever really got mad at him for anything, ever. I don't think I was ever really resentful or angry or wanted to hurt him. He was one of the first guys that I didn't really want to hurt. He was just a nice guy who couldn't handle going to jail or his own life, so I said, "Listen, let's work it out. Do what I did, go into a drug program. You get yourself known as a fucking drug addict; you get on a methadone program." At this time I was on the methadone program. For twelve years I couldn't get off of methadone. I was on 120 mg of methadone, still trying to shoot a thousand dollars worth of dope a day and couldn't even get high. Chuch is going to court, we're dealing drugs, life is a fucking mess, and we're still out partying with the girls trying to have a good time, watching the court cases, trying to be big shots, still dealing the heroin and other drugs and making lots of money.

A couple of months into this case, we're going down to Chuch's house one night and we see a whole bunch of people outside his house. The cops are stopping us from going in. Chuch was dead, he'd been dead for two days sitting up in his room. He had this little tiny room up in his mother's house, and he kept his motorcycle on the porch. His room had stop signs in it, mattresses on the floor, a real sixties pad and we all used to gather there. His mother never bothered us, his father never bothered us, we could come in and say, "How you doing" and walk upstairs. When they found Chuch he was sitting up like a little Indian, with his feet and legs crossed. He was slumped over, dead. He had taken a lot of barbiturates and methadone and he'd started snorting dope, which he'd tried to stop and didn't want me to do. This is what we all didn't want; we didn't want nobody to start on this shit that's gonna take us down for the big count, which is dope. At this time we were doing a lot of dope.

CHAPTER EIGHT

Michelle

WHEN CHUCH died, I was going out with his ex-girlfriend, Michelle, who later became my second wife. She was using, I was using, and it was pretty wild. I remember getting high in the bathroom at Chuch's funeral, shooting dope. That's just the way it was: you're a heroin addict, you shoot heroin and there's no boundaries. It doesn't matter. I shot dope in front of my daughter, I shot dope in the house. It's just the nature of the disease. Chuch got mad at me for hanging out with Michelle. He was pissed about me seeing Michelle even though they had stopped seeing each other. He had another girl, Sally, that he hung out with, but Chuch was still having a tough time with me going out with Michelle during the couple of years that I was partners with him.

After Chuch dies, I didn't wanna get married, I was a drug dealer. I didn't have a job, I was on fucking probation now, again for the big drug charge. I got busted and got five years probation

after going to court for two years. I was still a dealer, they caught me with guns and drugs and paraphernalia and they wanted to give me seventy-five years in jail. I had a good lawyer that got me out of it and I wanted to stay out of jail. I didn't know how to do that, being a drug addict and being in a methadone clinic, picking up my methadone everyday and still using, still doing 120 mg of methadone and still using coke, heroin, any dope.

I wasn't supposed to have Michelle in the house when the probation officer came and caught us. He would catch us on the Parkside, he would catch me in every fucking place I was not supposed to be because I didn't give a fuck for him. I didn't care. "Fuck you, you're not telling me. I grew up in Park Slope, in this neighborhood, don't tell me where to sit." "I could lock you up. I told you to stay out of the park." I looked at him and said, "I'm not in the fucking park, I'm outside, I'm on a bench, leave me alone, don't bother me." I was very resentful and defiant with the Probation Officer.

He used to come up to the park when me and Michelle were going out. He would say to me, "You know, you can't be with her, you're not supposed to be." Even at this time we weren't supposed to be together because we were both drug addicts. You couldn't be with another person who is a known criminal or has a felony arrest. They didn't want me with her because they thought she was a bad influence on me and I was a bad influence on her. He told me I couldn't get married. He said I couldn't hang out with her. There wasn't a thing he told me I couldn't do that I didn't go out and do anyway. I just was very defiant.

He hated me and I didn't blame him a bit. Part of him was doing his job. I just think they didn't know how to do their job. If it were me, I would try to understand somebody that I was dealing with and show them more concern, more love, show them the way, tell

them when they did good things. I would try to point out where they're gonna wind up if their behavior continues. Instead, they waved their handcuffs in front of my face and threatened me. I said if I get married and I have a good life and I set up a house or an apartment, how the fuck could they possibly object. It was crazy.

Being that we were living together, or Michelle was coming in my house and staying with me overnight, her mother said, "Oh well, it would be better if youse two got married if youse are gonna carry on like this." The truth is I was still married to Pat. I was very hurt from my first marriage, I never got over it, even going into my second marriage. Before we got married I had to get divorced. I did do that.

I wasn't supposed to get married when I got married, but me, Michelle, methadone, and heroin got a marriage license at City Hall. My brother-in-law Herbie was the best man and we had a little thing in a restaurant. We lived upstairs in my sister Margie's house, which was a disaster. We were both using. I would go to work, Michelle would be stoned on pills and dope, she was falling down staircases, getting hurt, getting fucked up . . . it was terrible. I would come home and find her laid out on the floor or stoned somewhere. Not that she didn't find me laid out on the floor and stoned.

I got a woman probation officer after a while. I had to show that I had a job, a bank account, and that I was doing good to get off probation. From then on in it was a little bit better. I liked the woman officer, she liked me, and we got along great. I got more from her, more kindness from her. She got me a release after two or three years of being on probation from that big case. It wasn't the last time I went to court and it wasn't the last time I was in jail.

The children were still with the woman on Fourth Avenue and Eighth Street. Now they're getting to be about six and seven years old. Michelle's parents buy us a beautiful two-family house on Frail

Place, right off of Coney Island Avenue—Italian marble floors, rugs, furniture, everything. I can't even imagine this. We get a tenant, it's great. It had three bedrooms, I built bedrooms downstairs for the kids in the basement. Bob, "Bengie," my oldest son has his own room, Carrie, my daughter, has her own room. We proceed to live there, being on the methadone program and me working with my brother-in-law as a steamfitter, working and trying to put my life together.

At this time we have our first son Keith who is born with a methadone habit. He stayed in the hospital for a while and then we took him home. In an old Italian family the first-born male should always be named after the grandfather but I named our son Keith because I was arguing with my father-in-law, Dominick, at the time.

Our second son was also born with a methadone habit. I'm not blaming myself for the kids being on the methadone program; I mean Michelle and me being on methadone and my sons being born with a methadone habit, detoxing in the hospital for a couple of months, going up there and watching them with these tremors. I feel very guilty and ashamed of what I did and for what happened, but there's no way I can blame myself for being an addict. I was addicted to heroin, I was a drug addict and I knew at that time there was no way out of it. Now I was in pretty good graces with my father-in-law, so this son, Dominick, we named after him. I love the name Dominick, too. When we named our son after him he was real grateful. He always truly loved the kids, his two grandchildren.

Michelle's mother and father were very good to us, they treated us well, they bought us cars, televisions, a refrigerator. They were our greatest enablers—that's what they did. And we were two strung-out heroin addicts.

Our house turned into a shooting gallery. I remember not shooting anything, any kind of drugs for a couple of months. Then

somebody would bring something over and I would test it for them. I would tie up and shoot it to see what it was. The house turned into a crazy house—women and sex. Women came to the house and if they wanted to have sex with me I had sex with them. No matter which woman came into the house, it didn't matter to me. I was cheating on Michelle and Michelle was cheating on me.

The kids, Bengie and Carrie, are in the house at the time and have to spend a lot of time in their rooms down in the basement. They heard and saw so much. They saw people OD, they saw me carry them out of the house like a dead body, they saw me put them in cars. My daughter came up out of the basement one time and actually saw me in the kitchen with a needle in my arm. She must have been seven or eight at the time. I told her to go back downstairs and she turned and ran back. They were told not to come up, and they knew enough not to come up until whatever we were doing upstairs was over. Sometimes it stayed like that for two or three hours. They watched me and Michelle OD. Her mother and father came in one day and took the kids right outta the house. We both woke up on the floor. For the kids it was a torture, we tortured them with all these crazy people that came around, all different times of the day or night. When you're dealing drugs people would bang on your window at two or three o'clock in the morning. They wanted something, they needed to come in, they wanted a place to shoot up. It was fucking crazy.

In the basement with the kids I also had a safe filled with money. Holy Christ it was incredible what took place in the house . . . always living in this state of anxiety that goes on forever. Every day you get up, you leave the house. If Michelle wasn't there or if Michelle was stoned, somebody else was there minding the kids. She would get high without me. We would fight and blame each

other for what went on. We were always fighting. Battles every night, throwing shit out the window, cops coming to the house. I was very physical with her, she was very physical with me. I would go out sometimes on Friday night after work and sell some drugs and not come home until fucking Sunday, just calling her every couple of hours. I'm here, I'm there. It was nuts, it was fucking nuts.

It was very painful living in the house and it was very painful in the marriage. The kids were in terrible pain and they led a terrible life. We tried to have them going to school, I tried to do the football thing with them. We tried to do the fucking *Leave It To Beaver*, *Ozzie and Harriet* type of thing, but it was an impossible task. I was making a ton of money, that was the most important thing that I could do; the most important thing I could do was make money. As long as I made money, everything was fine. The kids were getting older and they were getting fucked up. They hated me and they hated her, but what could they do? They couldn't do anything just as I couldn't when I was a kid with the shit that was going on in my family.

There came a time when I was in the bar one night. I just came back from robbing somebody, we had a lot of drugs, I was on a lot of speed—it was called Dysoxin at the time. I used to soak twenty or thirty Dysoxins in a bottle, mix it with some cocaine after it dissolved in the bottle and it would turn into a urine yellow, piss-like color, and you'd know it was very strong. These pills, you couldn't break them or nothing. They had to be heated up in hot water to dissolve, and when you suck all the chemicals out of them, that was Dysoxin, that was speed. Then I used to draw that up, shoot it and go totally out of my mind, whacked out. I loved being on speed, running around doing a hundred different things. Your mind was so spaced out you didn't know where you were.

I had just came back from this guy's house who owed me a lot of money and I had two .32 automatic pistols with the clips in them. We're all sitting in the house and I got this dope out on the table. I put some of the money on the table. Everybody's getting high, wandering around. Michelle is sitting on the couch and I'm cocking the gun trying to take the clip out. I took the clip and shell out of one gun, because when you're in a house full of addicts you can't have loaded guns around. I go to do the same thing with the other gun and I'm turning around facing the wall so nobody's in front of me and I take the clip out, and then I go to take the bullet out of the chamber and it won't eject. As I'm doing this, I'm talking. There are people asking me questions like "Are we gonna do this? When are we?" . . . and I'm saying, "Shut the fuck up. Just let me, relax. Sit down. Let me finish this. One thing at a time. Let me get this done." My head's wacky. As I turn, I lifted up the gun and I hit the back of the gun with the palm of my hand to put the barrel back up front because somehow or another I thought if I hit it the bullet would shoot up in the air. Well the bullet didn't come out. It went back into the chamber. I hit it, the gun fired, and the bullet went clean through Michelle. She was sitting on the couch. It went right in by her thigh and came out the top of her belt, clean through her into the couch. And all she did was say, "Ooooh, I'm shot." I looked at her and said, "Get the fuck out of here, you're shot." And all of a sudden we looked at the dungarees and we saw this blood, and it's pouring out all over the fucking place.

They were all yelling at me, "You gotta get rid of the guns" and I'm saying, "No, I ain't getting rid of no fucking guns. You gotta take her to the hospital." So a couple of the guys take her to the hospital. I can't go because they know me at the hospital. The cops will come in there and they'll say, "What were you doing with this person?"

So I tell them, "Youse got to take her and you tell them any fucking story you want. Tell them that the Puerto Ricans on Third Street fucking shot you. Blame it on them. Fuck it." So that's what they did. They went to the hospital. Detectives came in. They let her out of the hospital about two hours later. The bullet went clean through her leg, out the top of her leg. She still has the mark. It hit not one vital organ. All fat. It was like a million to one shot. Right through and into the couch. I used to have the bullet and wear it around my neck.

When the cops investigated in the hospital they said, "This is such a bullshit story," that she got shot coming out of a car going to get cigarettes. They said, "What happened? The guy come up out of a manhole cover to shoot you?" It was such a fantastic story but everybody stuck to it, so we got cut loose. Now Michelle's uncles, wise guys, wanted to know how she got shot. And they were saying, "Oh, these Puerto Ricans on Third Street . . . "And I'm saying, "There's going to be a fucking war." I'm thinking, they're gonna start shooting people and people are gonna get hurt. How the fuck are we gonna get outta this thing? Michelle wasn't saying anything, she told one uncle who was her godfather and a pretty big guy at the time, that it happened in a house and it was an accident. She's not saying who did it, but it was just an accident so don't go out after nobody.

Now two, three weeks go by and they want to know who caused the fucking accident. So they get Chuch and they say, "We want to know what the fuck happened." They sit him down and Chuch says, "I don't know. It was like this guy, his name is Bengie . . . " and he gives my fucking name. Nobody knew that it was me. So Chuch comes back to me and he says, "There are a lot of Bengies." I said, "Yeah? Where? How many fucking Bengies in the neighborhood does what we do?" So it was just so stupid and he copped to it, like he fucked up. And the next minute I was down talking to her uncles. I had to go

down and see them because at this particular time they found out what I was doing, that I was dealing. So I wound up doing some work for them, selling some guns, selling hundreds of pounds of reefer. Now I was this tough guy, and "wow, this guy is cool," or whatever the fuck they thought. Anyway, it all wound up okay. They didn't beat me to death or shoot me and they didn't take me out and whack me partly because I was married to Michelle. That was a big part of it. I was scared to death. I thought, this is it. I'm gonna fucking die. They're gonna kill me. You don't fool around with these guys. These guys are killers. They'll fucking murder you.

I was in the bar, I was drinking and a fight broke out. Michelle was with me and four or five other guys. They had me backed up against the wall and were beating me with bats and clubs. I had a big twelve-inch dagger on me and I stabbed a couple of guys and one of them almost died, actually both of them almost died. They were kids in the neighborhood. At this particular time I'm gonna be thirty-five years old and I'm still going strong with the drugs and everything, always carrying guns and knives. My dagger was like a big Mussolini Honor Guard knife—one of my antique knives. I stabbed this guy in the belly, the knife goes through his stomach. People are outside, I stabbed another guy. It was a terrible night. My wife was there.

I remember running away, holding the knife, blood all over me, then running down the block and into this couple outside a house. I ran into their house, they looked at me like I was I crazy and I told them to shut up and don't tell nothing to nobody, but within a half an hour the place was loaded with cops. They told on me. The cops came up and found the knife.

To me, still today, it was totally self-defense. I was protecting myself. It was a bar fight, I was getting beaten with bats, I was terribly scared and paranoid, and I did what I did. You back me against

the wall and I have to hurt you. It was pretty scary at the time. One of the guys that I stabbed was the son of a mother who worked with my mother in the Holy Family Home. I had to go to the hospital and be identified by the guys, but they couldn't identify me. They were both half-ass in a coma or something. I naturally denied the whole thing. They knew I was there, yeah, but I denied stabbing them.

From that day on no matter what I did in the neighborhood, the cops were locking me up. I was out on $10,000 bail at that time I think. When I stabbed these guys it was pretty wild. Now I was going to jail; there was no more probation. I went to court for about a year, I paid my lawyer, sold all the kid's insurance policies to pay this lawyer because I would do anything not to go. I wasn't gonna suck my father-in-law in for any more money or my mother or anybody. We paid for what we did. I told my lawyer I didn't wanna go to jail. He did the best he could and I wound up getting nine months in Rikers for attempted homicide or some shit—but it was broken down into a felony attempted assault and I wound up going away for six months.

At this particular time my father-in-law was gonna sell the house and get out because we totally destroyed the whole neighborhood. After I stabbed the two guys, people came to the house, broke the windows, and wanted to kill me. They put death threats on the door—notes with skulls and stuff like that. They wanted to murder me and my kids. That was part of why we had to leave—we didn't just sell the house, we had to get outta of the house. People had died. One of the twins across the street died, the daughter of a bar owner who hung out with us. These weren't the first ones, and they weren't the last ones. There would be many people that died around me. I just didn't know it then.

Jail

THE LAST couple of months before I was going to jail, the house was being sold and we were getting rid of everything. We had seven rooms to empty out, stuff to sell and give away. Michelle was moving into an apartment on Kings Highway. My two kids were going to one sister and my other kids were going to another. We were breaking up and, as they say, "Breaking up is hard to do." It was getting sad.

It was Father's Day, and I was on my way to jail. A cop comes over to me at the Brooklyn House of Detention and says, "You're in jail and you're here on Father's Day, what do you think about that?" I looked at him and I said, "So what, you're here too on Father's Day, what's the big fucking deal?" I was there for the crime and I wasn't with my kids. He was there for the money, and he wasn't with his kids.

Then I get to jail on Rikers Island and I'm saying, "What the fuck happened?" I'm thirty-five years old, I'm on methadone, I'm

sweaty, kicking, sick as a fucking dog because they don't know I'm shooting bundles of dope over the methadone. I get in there and go through all this shit. They spray you down with DDT, you take a shower and they throw you some clothes. I see the doctor and he tells me, "I'm going to detox you from the methadone—gonna put you in a fourteen day detox." I said, "Okay, we'll do that."

So as I'm walking up the corridor to my cell, all of a sudden one of the deputy wardens in white shirts pulls me out of line. Who is it but one of my best friends I grew up with? He gave me some money, put money into my commissary account and he says, "If anybody bothers you, try to get word to me and I'll straighten them out," meaning any of the inmates, any of the blacks or any of the Puerto Ricans. "If you get bothered by anybody you let me know." So that was a very comforting feeling to know that one of my good friends who I grew up with, drank with, partied with when we were fourteen, fifteen, sixteen, seventeen, and eighteen years old, worked on Rikers Island. I didn't know he became a deputy warden. Skippy was great, just to know somebody was there was reassuring to me. It was scary for the first time, and me a weakened heroin addict. He knew I was one of the guys from the neighborhood and he was taking care of me. I thought that was great, so I passed that little word around, naturally very quietly, that one of the deputies was one of the guys I grew up with. That little word got around, and I pretty much took care of myself. I didn't have any fights, I minded my own fucking business. I stayed with the white guys, which you have to do. Up there they got Harlem, Spanish Harlem, and the white neighborhood, and that's how the bunks go in the dorm.

Michelle snuck stuff in for me and I got high. She'd put reefer in these little tiny balloons and bring them to me in jail. I would

swallow them and then go back to my cell, drink a big glass of
soapy water and puke them up. If that didn't happen, I would have
to shit them out in a plastic bag and then feel for the little rubber
balloons between the shit, wash them off, get the pot and roll it up.
That's what I did in Rikers to get roast beef sandwiches and "tailor-
made jailhouse clothes," jumpsuits with pockets and stitching all
along the sides in exchange for some reefer. They would give you
a shirt; you're small and they give you an extra large. He cuts it
down, makes it a medium to fit you so you look good. You have to
look cool. It was important because what you did in jail—and this
wasn't even big time, this was a "skid bit"—gets around. I did all
skid bits in my life, ten, fifteen, twenty days, six months was noth-
ing. I knew guys that did ten, fifteen, twenty years. So I was doing
six months on Rikers Island, which was like being in the fucking
Plaza Hotel compared to going upstate. I was very grateful, even
though I didn't know the meaning of the word then.

I didn't want to be there, I wanted to get out. It took me two
weeks just to get out of bed in jail. It was about a week before they
helped me to the shower. I was so sick after I detoxed from the
methadone in the infirmary. I went back to my cell, back to the
dorm. They gave me nothing and I was sick as a dog for the next
two months. I finally detoxed from the methadone. That means
they gave you 20 mg, 10 mg, 5 mg, 2.5 mg, every day a little bit less
and after fourteen days in a hospital ward they put you into popu-
lation and you're supposed to be cured. I felt like a piece of shit,
like I was dying. The fucking air I breathed hurt. This is the first
time there's no toxins in my body, there's no flu like that, it's very
painful. Your legs, your joints in your body, all your bones hurt
like you've got arthritis, your hair hurts, your face hurts, your
fingertips hurt, you constantly got the dry heaves, you're always

throwing up nothing, you can't walk, you can't eat or drink, even though you might be able to put some water in your mouth and spit it out. Being on Rikers Island and being sick for two months from going cold turkey, you are physically and mentally a wreck; going to the bathroom all the time and constantly gagging. I was sick as a dog and swore to God I'd never get on methadone again, and that was the end of it.

I started eating a piece of bread with some jelly, a little bit at a time, a spoonful of beans. It took about two months for me to be okay and then after the following two months I was out of there, working with a gang called the Ghouls.

The Ghouls were the people who buried the dead bodies that were found on the streets of New York, and we buried them on Hart's Island. There was the Big Ghouls and the Baby Ghouls. The Baby Ghouls were the ones that buried all the babies from hospitals, stillborns, kids in car wrecks, unknowns. We would carve their serial numbers on the pine boxes because no one knew their names; they were unclaimed bodies. Some had IDs but no one claimed their bodies. We would dig a six-foot trench and put a pile of three or four on top of one another, then a bulldozer would come and throw a foot of dirt on them.

We had to go from Rikers Island to Hart's Island by bus. The bus would go onto the ferry, which was very scary. They'd open up the back door of the bus when you're in the middle of the ocean in case the fucking bus fell off the ferry. I said, "Yeah, and what, how do you get out of the fucking bus? You're dead."

When the guys came from the funeral parlors to confiscate some of the bodies that were numbered, if maybe somebody identified a body, we would dig the body up. These guys would come in the funeral hearse and sometimes they would slip us

some booze, a pint of Fleischmann's Rye whiskey or a pint of something else for digging up the dead bodies. They'd say, "It's in the back seat of the hearse" and we'd each take a few swigs, two or three slugs each, get a little buzz on.

We would go to the island and we'd stay there all day, from seven in the morning to four in the afternoon and come back. We'd feed the seagulls, watch the water, hang out, fry up the baloney, bury some bodies, dig up some bodies, and then go home. A day in the life of a ghoul, that's what we did.

I remember Michelle bringing my son to Rikers Island for a visit. I thought that was so cool; it was the fucking worst thing I coulda done. Why would I want my children strip-searched and seeing me behind a glass partition?

After Jail, Sally

SO I'M out of jail and back with Michelle. I brought all the kids together and we all lived in a one-bedroom apartment down on Kings Highway—we had a living room, dining room, and a bedroom. The two older kids slept in bunk beds inside . . . wow, I think we had all four children in one room, and me and Michelle slept outside on another bed. We were fighting, I was getting drunk before coming home, she was still getting high. She wanted to do her thing, I wanted to do mine. It just didn't work. It just didn't work. After six months we had this big fight and I said, "Fucking move out, get out of here." I was so crazy, I threw her furniture down the stairs and broke everything.

When I came out of jail I drank a lot. I got a job and I wasn't shooting dope, I wasn't shooting speed, no sticking a needle in my arm, but I was drinking very heavy. It was a very sad time in my life because I'd always be in the bar. Michelle moved out with

Dominick and Keith and I was alone with Carrie and Bob. They would have to come to the bar for me to give them money to eat. I would come home at night, fall asleep, wake up, and go back to work. Pat was in California and outta the picture by this time. She hadn't gotten in touch or contacted me for five or six years and she was never in touch with the kids until they were teenagers.

I worked at a steam-fitting outfit on Twenty-fifth Street. No matter where I went or what kind of job I worked, I found people that used drugs and I started using again. Everybody there was using or drinking at the time, except for a few of the workers. I was a boss on jobs out in the housing projects and I'd send stoned drug addicts over to Manhattan to get heroin. They'd come back and we'd shoot up. Even though my brother-in-law was the foreman, I would still disappear, get high, and nod out on top of the boilers. They would have to find me.

One day I had these gum sole shoes on and I was sitting up on top of a super heater. They turned the goddamn heater on because they were testing it and me and my shoes melted to the top of the boiler. I could've cooked myself nodding out while trying to tighten up a flange. Other times I would be leaning over and fall asleep mixing concrete, just nodding out right on the shovel.

My brother-in-law Herbie, my sister Margie's husband, always knew what I was doing. Naturally I'd lie to him a hundred times, but he knew. It's amazing that he gave me so many chances. Herbie always stuck by me. As fucking bad as I was, I always was a very good worker on the job. I would work till I dropped. I worked Saturdays and Sundays. Part of my working was why I was never home.

I was working and bought a car with a loan from the bank. I did all these phony loan papers and got people to cosign for me. So I got a loan, got a car, and I was driving around dealing drugs.

While driving I met this girl Sally and her husband who lived
in my old neighborhood up by the parkside. I was selling them
dope and one night I sold him some dope and he died. Not that
I killed him, he just died, and the next day I moved in with Sally.
My daughter came with me and my son went to live with this guy
Paul who was selling drugs.

Sally was a heroin addict. She was on social security and I was
dealing drugs out of her apartment. She was my girlfriend. She
had a fourteen-year-old son Leo who hated my guts, didn't like
me at all, hated to even be up in the house where I was. I remem-
ber when I was living with her and I started selling heroin in
the neighborhood. A lot of people found out and they put a big
banner, a sheet with a big picture of a syringe, saying, "Bengie
leave town. Get out of here junkie." And they hung it off the roof.
I fucking saw it and I said, "Wow, that's pretty cool, who put that
shit up?" But I never found out who put it there since everyone in
the whole neighborhood hated me.

Three of us go down to Ocean Avenue; there's a card game that
goes on there with six or seven guys. You go there and can make
yourself five, six thousand dollars. We go down this one night
about eleven o'clock. I knock at the street door, a guy opens it
and I smack him in the face with the gun, get him on the floor
and realize the guy's about sixty-five years old. He's going, "Please
don't hit me, please don't hit me, take what you want." I say, "All
right, all right." I tie him up, put a belt on him. We start to search
the house and I find ten cases of liquor, a couple of hundred in
cash, jewelry, and fifty rolls of porno movies that they probably
show at the card games. I even take a big ship that's on his man-
telpiece. I empty out the whole apartment. I have the guy tied up
on the bed blindfolded and keep telling him to shut up, kick him

in the ass once in a while and tap him in the head. Then I put a thing around his mouth and say, "Shut the fuck up." But I'm afraid to keep things around people's mouth for fear they can't breath or can choke to death, and he was old. So I take the hankie out of his mouth and tell the old guy, "Don't fucking say a word. Just shut up. Never mind what we're taking."

And being mean, I empty out his whole house into the car. I keep loading stuff. Everybody in the car is yelling at me, "That's enough! That's enough!" I'm saying, "Shut up" and I keep going back, taking chances. Then I go over to this big refrigerator. He was only one guy and I say, "What the fuck?" I know they feed people at card games, so I open up the freezer part and see fifty steaks. I take all the steaks and put them in a bag, clean out his whole freezer. I go to the bar where I hang out and sell the liquor one, two, three, and then go buy bundles of dope. We all get high.

I remember Sally cooking up the steaks. We're all eating steaks, drinking beer, smoking cigarettes, and watching TV. We're talking about how much fun it was and that everybody should keep their fucking mouths shut, and what I will do if anybody comes and tells me that I pulled a score. We did it, that's what we do to make money, and it stays here. And it did. But you still have to tell everybody that. I had no trust in people. At the end I did think about that old man. 'Cause he was old and I didn't want to hurt him, and I didn't.

I was with Sally for a number of years and that was a pretty hard thing. Sally would go out and make money any way she knew how and I would go out and make money any way I knew how. We'd come back, we'd shoot dope, we would cheat and lie to each other. By this time I had about $200,000 worth of antiques in the house. One by one I sold them until it was all gone and we

were living in an apartment that had no electricity, just an exten-
sion cord coming out of somebody else's window. All that was in
the refrigerator was green mold and a bottle of water. The apart-
ment turned into a real ghetto-ass apartment. I had sold every-
thing. I even took the mattress off the bed because the frame was
brass so I sold that too. This was all to keep our habits going. In
that apartment I was with Sally and it was all coming to an end.

I started hanging out on Prospect Avenue with the drug addicts
back in my old neighborhood, which was probably the worst
thing I ever could have done. I was down on Kings Highway and
I moved back to the parkside where I got in more trouble than I
ever had in my life. Well the trouble was good because I just kept
going down and down and down until I lost the steamfitters job.
Then I had to collect unemployment and while I was collecting
unemployment I went into a detox. Pete, the plumber, helped me
get into my first detox at Long Island College Hospital.

I stayed clean for about two weeks. Then I started drinking
some beer and doing some Valium, thinking it was okay, that it's
only beer, it's only Valium. No big deal, it's not heroin. It was a very
sad time with Sally because Sally was a heroin addict and she did go
out and prostitute. And I went out and prostituted myself in differ-
ent ways. Now I'm getting older and older, I'm almost forty years
old and just wanted to get clean. I had gone in and out of detox,
did thirty days at Kings County Hospital. But they didn't have a
rehab then. I just came out.

So living with Sally was very very painful because there were
a lot of people in the neighborhood who liked her and her son,
and all they did was put me down. I was the guy that was fucking
them up, Sally and Leo. I was the guy who was bringing people
up to the apartment. There were big guys that didn't like me and

I caught a couple of beatings from them. It just turned so bad in the neighborhood. I got my arm broken. Me and Sally owed the landlord a couple of thousand dollars' rent and he was throwing us out.

Then Sally moved over to her mother's building. She got an apartment around the corner on Reeves Place and it was kind of terrible, really bad living in the same building with her mother on the ground floor. Her window faced the stoop and she could see me come and go all the time. She would shake her head, "No! I don't want you in there!" I used to have to sneak in and out. At this time me and Sally were winos and it became worse. Her son Leo just did not like me and I couldn't blame him. If my mother was living with some fucking drunken drug addict who everybody in the neighborhood hated, why shouldn't this kid? He just lost his father, who wasn't really his father, now he's got another guy who's not his father.

The bottom was coming. I had lost my job and I couldn't even get another one. I was on public assistance. I was so bad, I kept going into detox. I couldn't see what was going on; couldn't figure out what was happening. I think being with Sally at the end was probably the most painful time in my life because I suffered a lot of humiliation. It was a vicious cycle, a vicious cycle. I bounced from the frying pan to the fire, from Michelle to Sally. Although Sally was a really nice person and she did like me a lot. The only thing was, it was a very very painful time in my life.

When I was living with Sally, my sisters and all them didn't even see me, and I only lived two blocks away for about two years. They knew I was on Prospect Avenue and they were on East Third Street, but nobody could find me. They knew my life, they heard stories about me, but they didn't see me.

CHAPTER ELEVEN

Bad Crimes

MY TWENTIES and thirties were when a lot of things happened.

We were sick. On July 4th we had fun putting cherry bombs in big ash cans underneath the benches in the park, setting off explosions while people were sleeping on the bench, blowing them up from underneath. We knew it was a loud noise, but we had no conscience, we would laugh. If they couldn't hear for a month, we would laugh.

There was an old man who had one leg, a bookmaker, sitting on a barstool. This other guy in the bar, Jimmy, took an ash can firecracker walking up to the old man and put it in the guy's jacket pocket—lit. Then Jimmy walked out of the bar and this thing went off. The bookie jumped out of his chair on his one leg screaming all over the place, burnt from his knee right up to his armpit, all burnt.

One time I had a fight in the bar and this guy hit me once and broke my nose. Then one of the big guys hit him and knocked him

out. I dragged the guy outside and smashed his face on a Johnny pump, a fire hydrant, while he was unconscious because that's what they wanted me to do.

So where did we get the ideas to do this stuff? I saw it done from the time we were kids, I saw lots of mean things done. I seen the big guys punch faces in until their teeth fell out of their face. I seen guys get their eyes knocked out. I seen guys get bats over their head until their fucking heads split open. I seen guys get hit on the head with stools and the stools break, and I thought, "Wow, he got him with one shot."

One night a friend of ours came in the club and said that his daughter, I think she was around twelve or thirteen, got raped by this guy, this Spanish guy. He was somewhere around, I don't know, maybe thirty, thirty-five years old and we're in our twenties. So me and Jimmy, who is six-four, two hundred and sixty pounds, decided, well, we're not doing anything so let's go see if we can help. We're high, we've been getting high, shooting dope and coke and I'm in the mood to hurt somebody anyway. I used to get that way, get in the mood to just go out and beat the shit out of somebody. We would go to a bar or club or somebody's house and just beat them up if somebody wanted us to do that.

We had a car but it was never legal, we never had insurance or licenses and shit like that. We just drove. Meanwhile we've got the guns in the car. So we started looking in the neighborhood, on the south side and the north side of Williamsburg, going up and down the streets. All of a sudden one of the guys in the car, the girl's father, spotted this guy and he goes, "There he is! That's him, that's the guy, that's the car." So on a one-way block Jimmy starts driving the car backwards at about sixty miles an hour down around the Williamsburg Bridge and we jumped out.

The funny part about this is that me and Jimmy dressed up with trench coats on. A lot of these drug addicts thought we were cops, and we did have badges and shit like that because we used to do that when we went into clubs. We'd flash a badge and go into the after-hours clubs. Because Jimmy was so big nobody even questioned him for Christ's sake, he was so huge. That was a lot of the ways I would get to drink a lot for nothing, too. Not that we just walked and bogarted our way in, a lot of times they thought we were "the man" and we would show a little badge and walk in.

So we get this guy in the car. I handcuff him, I handcuff him from behind and I've got him up on the backseat. We put this blindfold on him and we're driving around for half an hour. Then all of a sudden we just say, "Ah, fuck it. Let's just beat the guy." So I start beating the guy, beating him with the shotgun, I'm beating him in the head. I put the gun in his mouth and knocked all his teeth out. Jimmy was beating him too. We were all hitting him. We dragged him out of the car and I broke the gun, the wooden stock, over his head. The guy was so out, unconscious, it wasn't funny. Then we just left him there.

*

WHEN I was thirty-three we were down on Kings Highway hanging out at the bar. At this time my old friend Pete was in the hospital with some kind of spinal meningitis, fluids to his brain. Pete was my best friend and would have done anything for me. He was a very big bodyguard for me, a protector because I lived with a bunch of tough Italian guys in the neighborhood. So when his wife was all upset telling me that their oldest daughter's boyfriend, and possible future son-in-law, supposedly had fondled

their younger nine-year-old daughter, I went up the stairs to the second floor where this guy was living in an apartment over the bar. I had in my hand the leg of a table, a big wooden leg of a table. I walked in and this guy was sitting at the kitchen table with his girlfriend. I laid the bat against the wall and he didn't even see it. I told the girl to get up and leave the kitchen, I wanted to talk to the guy. As she left the room I picked up the bat and whacked the guy, I whacked him in the head. His head started bleeding. When you're walking up to somebody and you hit them, if they don't retaliate you get this feeling like you've got the power now. He's not swinging back, he's covering up his head. Now what you want to do is beat him more because now he's a little punk. I must have hit him five or six more times.

He knows what he did to this little girl, so, "Why can't you be a fucking tough guy now? Why don't you be a tough guy now, you bastard?" So as I go with that through my head, as I keep saying that, I think of doing something worse to him. I'll kick him in the balls, I'll kick him in the face, I'll mash his face up, I'll try to break his ankles, his feet. This is as you go along, and when I see nothing is working I say, "I'd like to cut your fucking head off. You need something to remember, because we'll remember what you've done to this little girl." So that's when I took out the knife and just started hacking away at his hand. I put his hand on the table and I cut his fingers off, two fingers, all the way at the top of the fingers, and the blood just started shooting out, it was all over the place. His girlfriend was screaming like hell and I told her to shut up or I'd knock her teeth out too.

The guy was fat, a short fat guy. I was trying to throw him out the second-floor window but he was so fat, he was probably about 180 pounds and I was 120. I kept trying to get this fat

bastard up to the window, and every time I'd get him halfway to the ledge, which was only a couple feet off the floor, I couldn't lift him up. He was like dead weight, half-unconscious. So what I did was drag him over to the hallway door where there was a flight of stairs that were made of worn linoleum with those old metal rims. He was lying there, so I took his legs and pulled him over until he just went rolling down the whole flight of stairs. The amazing part is he jumped up when he hit the bottom, in shock, his blood squirting out of his hand, and he took off, he ran.

He's lucky he didn't die that day. I was going to cut his head off. His hand was bleeding like hell. I don't even know if the fingers totally came off but I know I had the whole hand on the table. He never came back. He never came back to Brooklyn. He knew what he did because he admitted it, and then he said, "I'm sorry, I didn't mean to do it." He had fondled this little nine-year-old kid when he was in the house alone with her and he almost raped her. The kid was in shock, so I just thought I would fucking put him in shock. I never seemed to have a problem doing something like that—taking somebody and cutting their finger off or some shit like that. Oh yeah, Pete's still alive today, but we don't see too much of each other.

<p style="text-align:center">*</p>

I HAD gotten a dog for my son and daughter, and my son named him Rocky. He was a black-and-white mutt, but he was huge, a big huge dog. From a little tiny puppy he got bigger and bigger. I really loved him. He used to run and jump and pay attention to me, but later he would run and hide under the bed when I came yelling, he'd go under the bed and flatten out. He was so huge, but I intimidated the poor dog.

At the end of my addiction we were getting thrown out of the apartment house and I couldn't take the dog with me. I didn't know what to do with it. Once somebody on Staten Island took him but then they brought him back to me and said they couldn't keep him. So I went to Pete and said, "What are we going to do? I don't know what I'm going to do with the fucking dog." He says, "Well, let's fucking shoot him," so we took him over to Cropsey Avenue and we put five bullets in the dog's head. We killed the dog.

I never forgot that, it kept me awake for months. I told the kids I gave the dog away. My daughter always said, "It's a good thing you gave Rocky to the people," and my son, he still doesn't know, he thinks I gave it away too. I would have had a real hard time telling him I killed the dog because he already thought I was bad enough, so how could I tell him I fucking killed the dog? I loved this dog.

When I came out of jail on Rikers Island I went back to work with Herbie, my brother-in-law. Our first job was at the Bronx House of Detention. Pretty funny. One of the firemen had some kittens and asked me if I wanted one. I said, "Yeah, give me the red and white calico kitten." I called him Red. When I left Kings Highway I brought him with me to Sally's house. She had two cats and they started fighting all the time but then they gave up. I was using a lot of cocaine and shooting coke and dope and I was nuts one day. I get in the house and my cat, who was three or four years old and big, wouldn't let me in the bathroom. He was growling at me like a fucking dog. I couldn't believe what was going on, I needed to get this fucking dope in my body. I was so sick, I needed to get in. I took a piece of rope and taped it on a stick and made a hangman's noose—the same thing the dogcatcher has. I got the cat by the fucking neck and just shook him. I tightened the loop up on his neck, then went over and opened the window. We lived on the third

floor and I just flung the cat right out the fucking window and he landed in the back of the yard. He always wore a red collar with a bell on it. I really loved the cat, but he wouldn't let me in the bathroom and I was very sick, so I killed him.

We lived there for two years after that. I remember the summer passing, the winter passing. In the winter all the leaves blew away, and there he was, his body. A skeleton body, with a red collar on it. Every time I got high and looked out this fucking window, I felt so bad, but if somebody walked into the house, I said, "Hey, look what I did to the cat." I couldn't say how bad I felt about killing this cat.

I made things love me and then I fucking destroyed them. There wasn't nothing that you couldn't do with the disease of addiction. It's a lifetime of anger, a lifetime of hating people, and people hating me. When I was mean, I was very very mean and all my life I never wanted to be mean. Everything I ever did, two, three hours later or a day later, I regretted, but I would never tell anybody because that was a sign of weakness. If I shot the dog I'd walk around bragging about it, "Don't say nothing to the kids but I put five fucking bullets in his head." I remember when I shot the dog, or I should say when Pete shot the dog, I was holding him and he was fighting back. I remember this fucking dog looking at me saying with his eyes, "What are you doing? What are you doing this for? Just let me go." And I couldn't let the dog go in the street, which I should've, just let him go. I thought it would be better, like playing God. One reason I did this is because the dog used to eat thirty dollars' worth of food a week and I couldn't feed him. I couldn't feed the dog, the kids, and my addiction.

*

A GIRL Carol robbed me one time. I brought her to the house and gave her some speed and some acid and I fucked up her head. I kept her on speed. I had this guy Eddie with me in the house and I left him with her for a whole night. It was like holding a hostage, she was a hostage. I drove her so fucking nuts that she wound up in a mental institution a couple days later. That was my goal, to drive her totally out of her fucking mind for what she did. So I just pumped a lot of drugs into her and had her crawling on all fours, doing all kinds of crazy things and going nuts from the drugs. She did not leave the house. It was very sick stuff.

*

I WORKED with Johnny, a great burglar, a real expert who could get into any damn place. Johnny probably spent more of his life in prison than outside. We did lots of things together. We even looked a lot alike and he used to get locked up for me and I used to get locked up for him. We would burglarize houses of rich people all over, summer and winter, sort of like collecting their stuff.

One night we robbed this house on Staten Island; it was a cop's house, there was a picture of him in his uniform on the table by the bed. Little did we know there was somebody sleeping in the other room. They got up and we had to run out of the house. We took the cop's uniform and his gun and whatever we could hold in our hands. The snow was about a foot deep. We tracked through this snow, got in our car and drove up a one-way block, then crossed the expressway the wrong way. We thought we were fucking Bonnie and Clyde.

Another night with Johnny, we robbed a bookie's house on Ocean Parkway. It was New Year's Eve and we were all dressed

up in our suits. I put a .22 in my holster. We thought if we were all dressed up it would be the best way to do this thing. We knew about the house we were robbing, we knew the money was downstairs in the basement behind the dryer because the guy made loans to drug dealers. He'd lend them $20,000 and they'd give him $22,000 back in three days. So we got in the front door and we were going down to the basement of the two-family house, walking through with little flashlights. I got the gun out, Johnny and I went down to the basement and all of a sudden we hear somebody upstairs. There's supposed to be nobody home. We rang and rang the bell before we came in and nobody answered. We ran up the stairs and Johnny bolted out the door, got in the car and drove around to the front. I ran out the front door. I didn't want to turn around because if I turned and saw somebody chasing me, I'd shoot them.

There was a stoop with four steps covered with ice and I went flying out the door, landing on my face, cracking my whole eye open. I got up, ran for the Cadillac and dived in the back window with the gun in my hand. Now I want Johnny to stop the car so I can go back to shoot the guy that came out of the house because I cracked my fucking eye open. I have this massive blood coming down my brand-new suit. I had to go to the hospital and get these big stitches right into my eyebrow—about seven. I'll never forget it. We didn't even get anything.

Living on the Streets

I WALK around with my life in my head. It's inside my head. I see it if I'm on the train or in the street: if I smell it, then I smell myself. It doesn't go away. I can smell the smell in my head no matter where I am. I could be outside a house and if I want to think of that smell, of being dirty and homeless and wanting to die, I could. Really wanting to die but not having the balls to do it, wishing somebody would just take my life. I used to shake, not being able to hold anything in my hands, not being able to shave. It's a terrible, terrible feeling. I never thought it was going to end. I had something in my head for the ten years from 1960 to 1970 that told me that the way people thought in that decade was never going to end.

I was an old gunfighter at the end. Everything I tried just failed, it never worked out. I couldn't get back to the sixties, the old times. I couldn't bring back the money. If I had $10,000, I'm

gonna shoot $10,000! The funny part about it is, I never knew I
did this my whole life. That's why I never had any money. Every
time I thought I had a lot of money, I'd buy some drugs.

When me and my friend Joe—"Coney Island Joe," "Popcorn
Joe"—came out of this detox, the winter was coming and we were
hiding up in Sally's house. We got thrown out of one apartment
and tried sneaking in and out of another one on Reeve Place. It
was kind of like living on the streets because I couldn't get back
in there all the time. Some nights I had to sleep in a hallway or go
somewhere else. When I came back to Sally's house I had to sneak
in because her mother was at the ground-floor window. I snuck
in and hid under the bed from her son Leo. He found me and said,
"I know you're under there!" Very humiliating, very humiliat-
ing. I was never afraid of anybody, why am I afraid of this kid?
Why don't I just sit up in the room? Part of me knew, or thought
I knew, this kid's pain. Never mind what I was doing. I was doing
something I couldn't stop doing. I tried a million times, but I just
couldn't stop hurting this kid no matter what. I needed a fucking
place to stay; it was ice cold outside.

I remember me and Joe going up to my brother-in-law's house to
get a shovel off him so we could shovel people's sidewalks for drinks.
We shoveled taxicabs out in the snowstorms just to get four to five
bottles of wine. I would say, "Wow! It's snowing, this is good!" Walk
out, work our ass off, I didn't mind working. The benefits are good.
The wine was there. Getting up into Sally's house and being able to
get into some warm dry clothes, that was a big deal. Then that ended.
I had to get out of that house, they wouldn't allow me back in there. I
don't know if Sally got thrown out or what.

After Sally, we were living on the streets for a couple of years,
coming back and forth to Brooklyn. I was a shopping cart kid.

Once in a while staying with my brothers, cleaning up and then going back to the street, living in the park in the summertime, at night sleeping on the benches. I was living underneath the West Side Highway down by the meat markets with Joe, who was a short order cook. We also lived in a rooming house down in Coney Island where Joe had a room with one little tiny bed. We would both just cuddle up there and go to sleep. Joe would give me half of anything he ever had. If he had one cigarette, he made sure I had half. If he had one piece of candy, he made sure I had half. If he came back to the hole in the cellar with a pillowcase he said, "Here. You take it. I'll use something else. Don't worry about it, I'm used to this. I've been doing this longer than you." We were like two fucking very self-sufficient winos, but I was always in a lot of pain.

Living on the piers, using a pushcart, me and Joe went pushing up the West Side Highway to the East Side gathering things that people threw out in their garbage or would give us—suits, shoes, lamps—and we would walk it all the way down to the Lower East Side to the swap shops and would sell it for two to three dollars an item. Maybe a nice lamp or ornamental metal rooster we could sell for four to five dollars. People threw away really good stuff. If I owned a house in the country I would never buy anything. I would go in a van or a station wagon and find it. I would put little ads in the bakery. "If you don't want some furniture, I'd be glad to pick it up for you." You get people that would say, "Just call this guy up, he'll take it away."

So I proceeded to live on the streets and I'm going down. It was very painful. Very painful living in cellars on Thompson Street in the West Village; living in Washington Square Park and Tompkins Square Park back in the early eighties. I couldn't call my family.

They knew where I was; they knew what I was doing. It's like a
committee, The Committee, telling you, "You belong here. This is
where we got you, this is where you're staying. You did what we
told you and this is the reward! Total bankruptcy." So all I used
to think about was the millions of dollars I had, the houses I had,
the cars I had, the apartments I had, the gold I had and now I was
living with nothing. I had solid gold watches, coats, mink fucking
scarves, five-hundred-dollar boots and the big silk shirts, and I
dressed like a king. Now I was a bum.

I smelled. I lived in cellars, under the West Side Highway, and
on the piers with no bathrooms. We had a little hibachi inside the
pier with a hole in the ceiling roof, a piece of pipe where the rain
water would go into a big bucket and we'd get water to wash with.
I lived there with two or three guys, all bums—two black guys, an
old Spanish guy, Joe who was Spanish, and me the white guy. We
let other people in when they came for one day.

We would cook chicken on the hibachi, drink our wine, and
get high while hanging found velvet paintings and rugs on the
walls of the big enclosed dock. There were about two hundred
bathrooms there. It must have been used as an old sanitation
garage. There were one hundred stalls. None of them worked,
but we used every one of them as bathrooms. They were a block
away, so you could go to the bathroom there and it would never
bother you. The ocean would blow it away. That was our bath-
room. "Where you going?" "I'm going to the bathroom." Walk all
the way to the end so you wouldn't stink up. We would sleep on
blankets and mattresses that we dragged in, cook up stuff, go out
during the day and bring all your shit back, whatever you grubbed
up. It was terrible. The feelings I got walking in the streets were,
"Where's my life?"

I remember Joe having to shave me, cut my hair, cut my mustache out of my mouth, go out and get some food. I was losing the ability to communicate with people. I couldn't talk so good. I was losing it. I was becoming what they call a wet brain. I just didn't want to talk to anybody. That's the way I lived on the street.

One day Joe went out and he didn't come back for a couple of days. I started getting scared by myself. Bums are very treacherous; they'll kill you for a pair of shoes. I used to carry a knife with me and I threatened to kill a few guys, chased them away. I told them I'd cut their fucking heads off and I did scare a few people. But not as much as I was scared. I was fucking frightened to death to be alone and be out there like that. I used to think about my children all the time, about my life, about the money I had, the women that were in my life. I used to blame it all on them, blame, blame, blame. So at the end, was my will dying? Yeah. My will was dying but I didn't know it yet.

I finally got a token off somebody and got back to Brooklyn to my old neighborhood. I think I went up to see Sally. I was hanging out on the parkside drinking wine all day with a guy named Bonesy. It was the worst place for me to go back to, my old neighborhood. Everybody knew me there. I had some friends that were also winos, the old timers. The cops were torturing me, putting guns near my head. Sitting on the bench I used to get humiliated, pissed on, beat up, talked down to. I wouldn't say a word, I couldn't say a word.

I was a terrible, terrible panhandler too. If people didn't give me money I wanted to kill them. I remember a guy telling me one time, "Why don't you go get a job?" and I said, "Fuck you, I worked all my life. I asked you for a miserable fifteen cents, you bastard." I used to get mad at people, so I wasn't good at

panhandling. Joe was a pro at it. He'd been on the streets for many
years and he had this rap with the cab drivers. "Hey buddy, how
you doing today? Nice day. Got a good cab there. Got some change
for an old partner?" Joe used to do a lot of the panhandling and
get a pint, a couple of pints, maybe half pint of vodka, two pints
of wine. He had a whole game. I didn't have that. "You got fifteen
cents? No? Fuck you." That's the way I was. So I wouldn't have
done very well on the streets.

I used to remember looking at old movies and seeing the
hero, the gunfighter, getting old and then people taking
advantage of him. I would think about those things while I
was on the bench, about how weak I was, how I couldn't fight
anymore. Didn't want to fight, didn't want to fight anybody.
That's why I let people beat me up. I was probably hoping to
die, or just didn't have it anymore. The world was dying, tired,
old. I lived the life of a man who should have been eighty by
the time I was thirty-nine. I stayed on the bench with Bonesy
hanging out, washing in the waterfalls, our usual shit. Then
we both decided, "Let's go to detox." It was a year since I was
in my last detox. I said to him, "Listen, tomorrow I'm going to
Kings County."

I went down to Sally's house that night and told her that I
was going into detox. So I went back up to the parkside at seven
o'clock in the morning, waiting for Bonesy. He didn't show up.
I says, "Fuck this, this guy isn't coming, let me start walking,"
because I had about a three-and-a-half-mile walk ahead of me.
It was June of 1983. I walked through the park. Sally met me. She
came with me to the last detox. I went in and I sat there shak-
ing and baking, shaking and baking. No booze in me, Sally ran
out and got a pint. I drank it outside, came back in still shaking,

sweating, stinking, sick as a dog. Thought I was dying. Really thought I was dying. A guy said, "I might have a bed for you." I said, "Alright, that's good." Waiting two to three hours was the most painful time of my life, waiting for that detox because I was so sick. Suffering from a terrible anxiety and the anxiety never went away for a couple of years. Every morning I woke up I was shaking, sweating, stinking.

But I did get into the detox that day. He said to me, "I got a bed at the end of the day," and I said to him, "Could you hold that bed till tomorrow?" And he says, "Nah, nah, nah, nah, nah. Either you take the bed now or you don't." So I did and I stayed in there thirteen days. When I went in, the guy was asking me questions and he said, "You were here last year, right? I remember you." I said, "Yeah, I was here last year"—my hands were shaking like I was mixing eggs, mixing batter, they were shaking that bad. The guy says, "Boy, you got them pretty bad," meaning the DDT's and "Yeah," I said, "Yeah, yeah, yeah." I had this big beard and fucking long hair and I smelled. The guy says, "All right, sign this," and he put a pen in my hand. I went to sign it and the pen went flying out of my hand. He says, "Never mind, you got 'em too bad." They put me in a wheelchair and took me up to the detox. I had a bladder infection, I had pancreatitis, my blood pressure was sky high. I was ready to explode and die.

The doctor told me at that point that if I'd stayed on the streets a couple more weeks the way I was, I probably wouldn't have made it. I probably would have died. I felt that way too. So no wonder I couldn't fight back. I was surrendering. This was the part where I was literally dying and surrendering and I didn't know it. I was surrendering to win. The will was gone. I had to kill the will. I had to kill the will that wanted to get high. I had to kill

the will to live again. If I had any money that day, I would have walked out of the detox. If I had $1.10, I would have walked up to fucking Ocean Avenue and gotten another pint of liquor, come back, missed the bed, and might have stayed out there a little while too long and died.

CHAPTER THIRTEEN

Detox

SO THE big mean guy, the big tough guy was going into detox again. It was humiliating because there you are coming back for the second time in less than a year. They gave me the bed. I sat up there at Kings County Hospital and I couldn't urinate for three or four days. I had a blockage and they're telling me to drink more and more water. One day I finally urinated blood and it was fucking painful. The nurses are sticking me with shots of vitamins in two-inch-long needles, sending that shit in my ass. You can feel it going into your body. I'm sure they gave me Librium because I walked around that fucking place like I was dying.

So I stayed for a thirteen-day detox and came out, I came out and I had a stick of pot with me and $1.70. This guy Panama who was in the detox became my good friend, he was a Panamanian barber. He cut my hair, trimmed my mustache, and shaved me a little bit. I was sick but I looked pretty good. I had thirteen days

and they're going to let me go home but I had nowhere to go. I
didn't want to go back to my girlfriend Sally's who's still using and
drinking. If I go back there, then I'm gonna fucking pick up again. I
gotta get to a safe place. So I headed down to my brother's house.

First I went to the parkside, sitting on the bench underneath
the trellis where I always sat. I looked across the street at the
bodega. I had $1.70 and went over and bought a pint of green
Ballantine Ale and came back. I stayed there for a little while and
thought, "What the fuck is the sense? I ain't gonna make it." I had
a half a joint that Panama gave me, it wasn't much. Every time I
looked at the ale and every time I looked at the pot I said, "If I do
this, I'm gonna fucking die." I got the message, a message came
into my head: "You're going to die." I never thought I was going to
die. My whole life, my whole thirty-nine years, putting guns to my
head, getting beaten, the way I shot drugs, the way I put stuff in
my body, I never thought I was going to die. That day something
told me I was going to die if I did it again. So I went down to my
brother's house. I left the bottle of ale on the bench, I flipped the
joint in the bushes, and I walked away from it.

As I walked away, the beer and the joint, the half a joint, was
calling me, "Go back and get it just in case. Come on, pick us
up just in case. Come on, get back here!" I got a block away, two
blocks away, three blocks away, and it kept calling me. I got so
many blocks away until I said, "I can't walk back, I'm too tired."
And I kept going to my brother's house. But that fucking bottle
of beer was calling me, talking, talking, it talks to you. Drugs talk
to you, it's a disease, they're the disease of addiction. The Com-
mittee, that was The Committee, they're up there and they're
saying, "Come on, it's only a bottle of beer, what's the matter?
What the hell? You bought it, you can't bring it back. Why don't

you just drink it? What the fuck is the matter with you? What are you turning into, a punk?" The voices in the head, the voices in the head. Sick and dying, fucking liver popping out of my side, my pancreas and everything else, I'm ready to die and this Committee is telling me to come and drink this bottle of beer and it'll be okay. And the little person on my shoulder is saying, "You're gonna die. You're gonna die if you do it." This is the first time I'm hearing this voice.

I never had thoughts that I was gonna die. I thought I was invincible. How could I possibly die, get the fuck out of here? Shoot the dope, shoot the coke—a ton of it—put it in. Shoot ten sets of works, fill them all up, shoot them one after the other, speed-trip. I never thought I would ever die.

As I got three or four blocks away I was really too tired to walk back. I had a couple more miles to walk, I had a heavy shopping bag and I was dragging it. I'd just spent thirteen days in a detox and now I'm wondering where I'm gonna eat because I was eating three times a day. I was on the streets and I don't want to stay on the streets at night. They let you out of Kings County at nine o'clock in the morning. I got all the way to the Parkside about nine-thirty and stayed there until about eleven, just hanging, talking to myself, mumbling, then I left. It was about two o'clock in the afternoon when I got to my brother's and I said to him, "Listen, I wanna come in."

He was sober about a year at this particular time and he said, "All right. If you come in, you have to go to a meeting with me tonight." I says, "Look, Sal, don't fucking bother me about these meetings, please. I don't want to go to the fucking meetings. I tried that with Sally, I tried going to the meetings, they wanted me to go to these fucking AA meetings. I just don't feel like going."

So he says, "Well, you can't come in, fuck you." He wouldn't let me in. So I sat on the stoop till around six o'clock. He came back out and says to me, "What are you going to do?" And I just sat on the stoop; I didn't want to sleep out at night. The sun wasn't down but it was a little darker. I knew in two hours it would be dark. I could sit on the stoop, but I was scared to death to be out at night. I didn't tell Sally I was out of the detox, but I did tell her the next day that I was staying at my brother's. My brother let me come in the house because I promised I'd go to the meeting two hours later at eight o'clock.

"Why don't you get ready for the meeting?" and I says, "Yeah, I'll go to the meeting tomorrow. I'll go to the meeting with you tomorrow, not tonight. I just got here, I'm tired, I was in detox and just came out, I don't feel good and I'm a fight fan and there's a movie on TV with Jack Dempsey that I want to watch." He says, "Pack your clothes and get out of here then. You're not staying here tonight." I says, "All right, all right, all right." I thought about it for a couple of minutes, the thought of being on the streets, in the dark, in the night by myself, fucking terrified me. So I went down to the meeting with him.

I never planned on getting clean, I never thought that I could get clean. "Once an addict, always an addict"—I heard this a million times. I never thought there was a way out or knew there was a way out until Narcotics Anonymous. Until I hit those rooms where I heard a guy say one day, "If you don't pick up, you can't get high." That was like God talking to me. Amazing. Now all of a sudden what went through my head was, "If I don't pick up, I can't get high. I'm the fucking guy who buys it. I'm the guy who puts it in my arm. I'm the guy who shoots that shit in my vein. So if I don't go get it, how can I get high?"

When I was three months clean, I got my first public assistance check and went down to cash it. I was walking up Ninth Street and Diane and Susan and a whole bunch of other girls I used to get high with are hanging out the windows calling me to come upstairs. Now I'm clean three months, got me ninety days. I'm feeling good, I'm healthy, and I'm looking good. I go upstairs to their house thinking I'm getting laid, this is good, "sex, drugs, rock n' roll." I get in there and they're all in their panties and bras and the coke is on the table and my fucking body starts shaking. *Boomboomboomboom.* They had a huge pile of coke, dope on the table, money all over the place, and they were sitting there arguing. "Oh Bobby, stay, Bengie, c'mon honey, let's get high. You want some?" They're flashing me and I'm saying, "No, no, no, I really ain't doing it, I'm clean ninety days." My fucking wheels are turning in my head. They were arguing over five dollars. I spotted the argument and remembered what they told me in the rooms: listen to the insanity behind the drugs. We could have a kilo of dope and argue over a little tiny bit that was left on the table. We could have a pound and fight with each other, wanna kill each other, because that's the addiction. I was watching the girls fight over this five dollars and I said, "What? I gotta go. I'm fucking out of here." I went down the stairs, took off and got on the train. I knew there was an AA meeting on Kings Highway and I went right away but I didn't share 'cause I wasn't talking yet. I did speak with a guy I knew there, an old dope fiend, about what just took place. And he said, "Wow, that's good."

For my whole first year I didn't really want to get clean. What I hear in the rooms is that if you repeat the same behavior you'll get the same results. So being clean I can't do no robberies. But I do. The program teaches you that if you make all this money you're

going to shoot dope. Well, when I have the money it was pretty tempting to go get high. But I don't. When I'm six months clean some guy wants me to pick up fifty thousand dollars for him. The reason I do this, they're giving me a thousand bucks. I don't have any clothes, I need clothes: this is my rationalization.

So I'm in the car with this other guy, the driver, out in Long Island in this suburban area and we're picking up fifty thousand dollars for these two Jewish high school teachers who are the bookmakers. I can't believe it. They run their little gambling thing out of Seagate, in this big house right in Coney Island. You'd never know it if you were to look at them, two nice Jewish boys. This is their thing and we're picking up the money for them.

When the cars get to Long Island, the two guys in the front car will go pick up the money and the backup car, which is me, will stay a couple feet away. If anybody comes after the front car, it's my job to intercept them. They think somebody is gonna rip them off that night. The guy who's driving says to me, "What kind of gun do you want?" "What do you got?" He has a .22 with a twelve-shot clip. "I'll take that," 'cause it fires twelve shots in a clip. The first car pulls up to the house, I pull up way in back of him. My friend Pete goes in the house and comes walking out down the driveway with this shopping bag full of money. All of a sudden a car pulls up in back of our first car. The guy that I'm with is saying, "Get them, get them, get them." So I aim the gun out the window 'cause I'm ready to shoot these people. And he's going to me, "Shoot them!" and I'm saying, "Shut up, shut up, shut up." Then I see two women step out of the car and go into the house next door. Pete just gets into his car and we put on our lights and roll away. I look at this guy and I say, "You're a fucking dope, you almost made me shoot two women."

When I got the fifty thousand dollars I said, "Fuck them two guys. This is fifty thousand dollars! They're two schoolteachers. What're they gonna do, say we robbed their money? Who the fuck is behind them? We're behind them. We're the ones that they hired. They ain't got nobody else. Let's just take this fucking money and forget it." And the driver, who was a bookmaker himself, didn't want to do it because he was involved with other guys that knew he hired us and we would've gotten in trouble. But let me tell you, I wanted to take this fucking money and say, "Fuck them guys." I would've went right up, right up to their house, and said, "Twenty thousand dollars is better than a thousand. That's what we're taking, so here's your thirty grand. We're taking twenty and I don't want to hear a word." But they didn't want to do anything like that. Six months clean and still I wanted to be a tough guy. I took the thousand bucks and bought some clothes. When I went to meetings, people said, "Wow! Where'd you get the new clothes?" "I did a little thing, a little score, ba-ba, ba-ba."

I also tested myself later when I went down to the bar I used to hang out at on Kings Highway. We were bullshitting and talking for a couple of hours. Now I'm clean and sober nine months. "C'mon, have a beer, you can have a beer, you can have a drink," and this guy runs a line of coke on the table and I said, "What? I gotta go, I gotta go." It was okay the first hour I was there, but as soon as a couple of people started to get drunk two hours later, it started to get very tempting to me. The club soda started tasting like a rum and Coke.

I knew what they said in the meetings. "You're an alcoholic, you don't belong in a bar. If you're a drug addict you don't belong in a shooting gallery." I knew I was both so I didn't belong there. I heard guys say, "If you sit in a barbershop long enough you get

a haircut." I says, "I gotta get the fuck out of here." Right over to the meeting two blocks away. I said, "Yeah, I was in the bar" and some of the old-timers in AA told me, "Hey, kid, you don't belong in a bar. You're an alcoholic, you got a drinking problem, stay out of the fucking bars." "But my friends hang out in there." "They're not your friends if they're in the bar. You wanna see them at the house, you wanna call them up, you wanna talk to them, fine. But you don't go in the bar to hang out with them." That's what they told me, and that's how they said it to me. "Yeah, all right. You're right, you're right." The guy says, "How'd you feel there?" I says, "I was fucked up." "You like fucked-up feelings?" "*No!*" "Then stay out of the bar."

Sue, Third Wife

WHEN I was on the parkside and I was a bum, I used to sit on the benches and dream. I used to daydream while I watched people go to work and think of having a nice family. I would see this woman walking down the block with this nice suit on and a briefcase and I'd say, "If I had a wife like that I would really take care of her. I would really be good. She's beautiful looking, she knows how to dress, and she wears her make up right, she's somebody who respects and is respectful and people like her." I used to sit there, drunk as a skunk, sometimes shaking from not having a drink first thing in the morning and say, "One day, I'm going to be with a woman like that."

When I got into the rooms of NA after a year clean, I spotted this woman. Her name was Sue. I looked at her, at her make up, her hair—at this particular time she had long hair—and it all curled like Angela Davis. She was thin with a beautiful shape and big breasts. She was fucking good looking. She was with a friend of mine that I used to get

high with, this guy Sammy, a Port Authority cop. In getting clean, we became friends. Sammy was very good to my children, but he was going with Sue and I used to say, "I'm gonna be with this chick." Every time I walked into the meeting I would look at Sue, she wouldn't be wearing a bra and it was so attractive to me. I would always hug Sue in front of Sammy and she would give me a hug. I knew there was something between us. In my head she was that woman I used to picture all the time when I was sitting on the benches, a bum on the Bowery. She spoke well, she was very articulate and she had a lot of class. Her make up was done right and she didn't let people shit on her. She stuck up for who she was. She was a real snobby, tough, sometimes arrogant, nasty person who had a lot of shit going on in her own personal life. But was I attracted to her! I used to say to my friends, "I'll be with her, wait and see." And they said, "Sammy will get jealous," and I said, "Fuck Sammy." I was so attracted to her. It was probably the biggest mismatch of the year. We were from two different worlds. I was this little tough Irish guy from Brooklyn—a wise guy; she was Jewish and French from Canada, beautiful and intelligent, and that was the attraction.

After two years of being clean, Sue went out one weekend and got high, did some pills or something and lost her time. Then she had to come back into the rooms. It was hard. I was there for her. I helped her because I wanted her. We went for coffee and I told her, "Listen, you get ninety days and we'll go out on a date, I'll take you out to dinner." So one day she got the ninety days and we went out on a date. She had broken up with Sammy and I knew I had a chance. I wanted to be with this girl. I just wanted to be with her. For some reason she was the type of woman I wanted in my life.

I remember going to this Halloween dance. She dressed in a skin-tight, zipper-up outfit like a cat, with a collar and leash around her neck. She was beautiful. What a body. She was just gorgeous—super

gorgeous. We talked at this dance and that's when we made a date
to go out. She invited me to her apartment for dinner in Carroll
Gardens. I loved it; it was a garden apartment. We had dinner and
we talked. I was going to leave without even giving her a kiss. I was
very shy and nervous, but when I leaned over the table and gave her
a kiss, that was the kiss that did it. We started tongue kissing a little
bit. We called it the Kitchen Kiss and she never forgot it. It developed
into a relationship and I started staying there Thursday, Friday, and
Saturday even though I had my own house in Bay Ridge. I had moved
from my brother's and had about two and a half years clean by this
time; now I'm dating Sue. We went steady for a year, lived together
for a year, then we got married. It was a marriage made in the rooms
of NA and everybody thought, "Wow. This is something. Sue and Bob
married! This is crazy." I started going by Bob when I got to the rooms
because too many people knew me as Bengie before. There were
even people out there that were after Bengie, so I decided to go by
Bob instead. So all of sudden it was Bob and Sue.

I used to walk down Ocean Parkway when I was a kid and think I
would never live there—it was too classy—doctors, lawyers . . . mean-
while, I'm married to Sue, we're looking at co-ops, and we get an apart-
ment through a friend of ours who had a building on Ocean Parkway.

The time that I was with Sue I was going to the school for read-
ing and writing. I was able to go to school and take a driver's test
and get a license. I went up there and took those twenty ques-
tions, and got seventeen or eighteen right, and I passed. It took
me five years clean time to get my driver's license. But I had a
driver's license that was mine, that was legal for the first time in
my whole life. I drove for twenty-five years with a phony driver's
license, one that somebody made up for me. And I had cars, and I
had them insured and everything else, but I couldn't go down and

take the test. Now I went down, took the test, and I got the driver's license. I went to the driving school; I got it. I did everything.
It was such an accomplishment. I was very very proud of myself
for doing that. And Sue was helping me, she used to help me read
and help me write. It was very good. It was very good.

We had a couple of really good years together. Then we started
growing and changing. We'd married in early recovery and now we
both were blossoming in different directions. We went to couples
counseling and really tried very hard to make the marriage work. We
were learning a lot about each other, about our character defects. I was
trying to change when I came home to say things like, "Hey, Sue, what
time is dinner?" instead of, "When is the fucking dinner coming on?"

We were both clean when we got married. She didn't know me
active and I didn't know her active. Her getting high was a lot different than my getting high. I was an IV heroin addict, a guy from the
streets. She was a Jewish French Canadian transporting drugs across
the border into New York. She did her little thing and I did my little
thing. Her thing was a lot of prescription drugs and other stuff, waking up on cold floors, dribbling from barbiturates and pills.

Sue's pain attracted me and she felt the same about me. She was a person who came from a dysfunctional family, just like all of us, and she was
really hurting. Her father was a prizefighter who verbally abused her and
her mother who died of a heart attack at forty. Sue used to tell me all
about her and I used to tell her all about me. That is when we got to really
love each other. But if your father abused you, you can't forget about it,
and for a long time it was affecting our relationship. No matter how good
I was, she found something to not like about me.

She was a very controlling person and we had a couple of big fights
about money. She wanted to cut up the credit card that she had to get
for me because my credit was bad. So I had credit under her name, but

I paid it, and we always had separate accounts so it wasn't 100 percent joint. She had a thing about money. She always thought she would be a bag lady if she went broke. I didn't make a lot of money, she made more than me, but there came a time when I made more than her. Then it was different. My value of money isn't so good. I know how to take care of the little bit that I have, but I would much rather buy something wonderful for her than buy myself a suit. I had millions of dollars and I spent it, because it didn't mean anything to me. I knew you could always make money, one way or another.

I just never thought that she would cut up my credit card, that she could do that. I got so angry and I was so mad at her that I picked up this iron chair and was going to throw it at her—kill her. I knew right then and there that I had to get out. I was tired of walking on eggshells about my feelings, tired of opening the door every night and looking to see if she was happy or frowning, what way was it going to be. We were not getting along at all. Should I touch her? It was difficult just living with her. Sleeping with her, I made sure I didn't roll over and touch her. I was paranoid about her. We slept in the same bed every night and never made love. I didn't want her to yell because I didn't want to get mad—I knew how I could react. Day by day, my feelings were getting hurt to the point where I started thinking, "I hate her." She thought that I would actually take her money! Her money! That's when I told her that I could take everything you have, just wait till you go to work and clear out the place. "What you gonna do? Tell the police? You gotta find me, and by the time you find me, everything will be sold." She was pathetic by that time. Her rational thinking went out the window. She only thought I would do this because she heard so much about my past. She already knew me five years.

All of a sudden one day I thought Sue started to get "too Jewish." We were hanging around people from United Jewish Appeal, she was

getting into the religion. I'm not one to do that, but I would let her do it if she wanted to. I don't want to get into any religion—I want to live my life on the Twelve Steps, on the spiritual level. I'd have to give a third of my salary to go to church—that's how I feel the Catholics are. If you don't give no money, they don't want to know you. I went to a couple of "Jack's" (Jewish Board of Family Services) retreats that Sue was involved with. She worked on Fifty-ninth Street at a big Jewish Organization UJA that fundraises and through her I met a lot of rabbis. I learned a lot about the Jewish religion and the way they lived. She started getting back in with some of her friends and her people, and some people I didn't like. They didn't like me because I was a *goyim* and some people didn't want me at Friday night services or Sabbath dinners. Sometimes I went to Passover dinners and a couple of real Orthodox dinners where some of the people really didn't want me.

We had tickets to go to Aruba on a fourteen-day vacation. We used to go on these great vacations even though we'd yell and fight about where to stay. I got very sick with pneumonia and was on a nebulizer for breathing. We were going to make the trip anyway. When I got to Aruba I got sicker and I was seeing doctors there. I saw the fear in Sue's eyes and I tried not to let her take care of me. I think she was scared that I was going to die or that she was going to have to care of an invalid for the rest of her life. That was a big part of our divorce, because the trip was in September and as soon as we returned we went to couples counseling. We were going in different directions. You want to be together, you try to make it work, you see you can't be together, you stop, you move on. It's not as easy as I say it because there's a lot of feelings and hurt.

One day in therapy, Sue and me just decided that it's over. She said we should get separated and I said, "No, I think we need to get

divorced. I don't wanna be separated. If I'm divorced from you I don't care what you do. If I'm separated, then I care what you do." With me it has to be a closed thing. I can't stand that kind of pain, watching my wife go out with somebody else when I am still married to her. We got divorced within three months and I left the house in December, two weeks before Christmas. The wind chill factor was well below zero. I was sick as a dog and could hardly breathe. A week later I got pneumonia. And I was fucking angry, forty-nine years old and by myself, again.

We stayed married for probably the longest I ever stayed married, four or five years. And the truth is, we really needed each other for the time that we were together and that's what counted. She taught me an awful lot.

So I found this apartment in Brighton Beach. I saw it in the dark, paced it off both ways with my feet—"I'll take it." For the first time in my life, everything gets split down the middle: the furniture, the videos, all the stuff. I was pretty happy with the way we broke up. At first we didn't talk, but after a couple of months we did. I made sure I never had to knock on that door again. I had everything that I needed, apart from an air conditioner. I was supposed to get the air conditioner, but she wouldn't give it to me. I had to go out and buy one because I needed it to breathe because of my bad emphysema. I'm breathing on a machine four or five times a day, divorced for the third time, and even being clean, I thought my life was over.

I used to stay in the apartment, cry, and say what the fuck is wrong with me. But I stayed clean. I was seven, eight years clean and thinking, what am I doing here? I'm in this apartment in Brighton Beach and I'm really fucking devastated that I'm alone. I don't know how to pay the rent, never had a checking account, never had my own TV, I never had nothing. But I did stay clean.

We didn't get along because she used to put me down a lot about where I came from. I came from cockroaches and she never lived that way. Actually we were both growing and learning about recovery at this particular time, learning that it doesn't matter where you come from or who you came from, the pain was the same. So we did get to know each other and our deep feelings pretty well. She knows a lot about my pain when I was a kid and is one of the few people who really understands where I came from and is proud of what I have made of my life. She wrote me a letter of amends a year after we got divorced, telling me how sorry she was for picking on me and calling me names. I never wrote her because I never felt I hurt her.

Sue was an actress and did some commercials. After we got divorced, she became a stand-up comic and invited me to one of the comedy clubs, Caroline's. I was in the back and her whole routine was about her ex-husband—me. And it was funny! I was seeing things in the marriage that I did that she found funny. She knew she could do that with me being there. That's a special thing. She knew she wouldn't hurt my feelings. I liked it. I have always supported her, she used to tell me that I was her biggest fan. I'm the one who taught her a few things about being proud of herself. The way I see it is, we were both very wounded children, and we know how important support is.

What was great after the show was when she was saying how proud she was to be my ex-wife and I held her hand. We hadn't done that in a long time and we both said, "This is great." Sue is a person who if I called her up today, she would be there for me. And I would be there for her. I just would.

During the time I was with Sue, I was going to school for reading and writing. I used to work all day and then go to school in the evening. A couple of months after we were married, we were down in a meeting and I met this black guy, Tommy, who was gay.

At this time you still didn't hang out with gay and black guys but Tommy was very nice and I liked him a lot. He always used to talk to me. I hung out with a lot of gay people when I was getting high and selling drugs because they were some of my best customers. Now I'm clean and aware of what people are going to think of me when I'm hanging out with this guy. It's very important that you talk about this bullshit stuff that goes on in your mind.

Tommy found out I didn't know how to read or write. He gave me a note one day and he says, "Call this number and ask for this woman Teri." So I said, "What is it?" He says it's an adult reading and writing school, and it's at Seward Park Library. "Where the hell is that?" He said, "East Broadway down on the Lower East Side." I called the woman and she said, "Yes, okay, yeah, you can come down." So I go down to Seward Park Library. I meet this woman Teri and another teacher, the first ones to ever test me. When I walk into this place I see Tommy. I didn't know he went there. I says, "Look at this fucking guy! He doesn't know how to read or write either." So it was good being around two or three people from the fellowship. Ray was there. Jose was there for a while. It was great.

The first time I had my own apartment, just before I moved in with Sue, I had to write a letter to my landlady. I was going to this reading and writing school. I needed to tell the landlady that I only had half of the rent and I would give her the rest on Thursday in a couple of days. I said, "Ah, I have to write this fucking note. How can I just put money in an envelope and leave it there? She ain't gonna know who it's from, and I gotta leave this money."

So I write this thing out. I took her name off the bell, *Ms. So-and-so. Here is half my rent. I'll give you the other half on Thursday. Bob Powers.* And I said, "She's not gonna understand this fucking thing. This is crazy." I left that money under her door

and I walked away. That whole day all I did was sweat. I felt bad. I wanted to go back and get it because I didn't want her to see how illiterate I was, that I was living in her apartment and I didn't know how to read or write. I didn't want her to know.

The next day I see her and she just goes, "Oh, Bob, I got your note. Everything is okay. Don't worry about it. Thursday is fine." And she never said nothing. I walked away and I thought, "Wow! She fucking read the note! I was right! Nothing was wrong on it. She understood it." It amazed me. I went to a meeting and I shared about it. I said, "I wrote a note today for the first time, and the fucking woman understood it. I panicked all day that she was going to think I was an idiot or a dope. I wanted to go back and get the fucking thing with a piece of wire and pull it back from underneath the door as soon as I put it under. Oh, what did I do, what did I do? This ain't right. I didn't even want to tell anybody about this. Then the next day she said, 'I got your note, everything is okay, Thursday is fine.' She understood the whole thing!"

These are to me spiritual awakenings. I never wrote a note in my life. I wrote a note, "Fuck you." I mean, that's what I could spell in the street with chalk since I was five years old. "Fuck you." And that's what I meant. " Fuck you, fuck you, fuck you, get away from me." And now my life was changing, my life was really changing. I was in school. I was learning how to read. We were reading to each other, reading books. They were sitting with me, a tutor, next to me. Every tutor I had took a liking to me, loved me, liked me for who I was. They were all sorry that they had to leave at certain times and they weren't gonna be back. "I would love to keep working with you, but I have to go on," maybe get married, or they were leaving. I said, "Oh, I'm gonna miss you too," and stuff like that. One of my teachers was a writer. I used to meet her at Marianne Williamson. She says, "Oh, I finally finished my book. How are you doing?" I says, "I'm doing good,

and this and that." "Oh, that's great, and oh! You became a counselor!" because from that school is how I got the job as a drug counselor.

A few friends told me when I got clean in NA I would make a good drug counselor and when I did get clean, they got me an interview to apply for a job. I went for three interviews and told them I didn't have a high school diploma but didn't tell them about my past. I had been a foreman on jobs, I was always good at managing people and they liked that. I got the job. It was only $22,000 a year, hardly anything. I worked for two women bosses, Eileen and Anne-Marie. It was the first time I worked for women and it turned out well.

Little by little they taught me how to be a counselor. I was nervous in the beginning doing groups, but from NA I knew what I was saying was correct. I asked, "What do you want out of this besides getting and staying clean?" Then I told the addicts I did drugs in the past. I was in therapy and could share with them what I learned in therapy and could pass it on. They liked it that I didn't lie, I told the truth. I really cared and it showed. I didn't tell them it was easy to stay clean. When you have no money, no skills, no job, it's hard. Many guys arrived at meetings "tore up from the floor up," a saying they used, but there's no harm in trying. The drugs will always be there. If you don't like what we tell you, the door swings both ways and you can easily leave.

But many took my advice and are now counselors and therapists themselves.

Daughter Carrie

MY DAUGHTER Carrie came to New York to live with me because she was having problems with her mother in California. She never took drugs. She never was an addict. She smoked for a year of her life, a cigarette here, a cigarette there . . . but she never had a drinking problem. Carrie became a born-again Christian at fourteen or fifteen years old. Then she met Peter. She met him in the rooms when I took her to Nar-Anon meetings. He was an addict, ten years older than her—a little tiny guy and she liked him. They started dating and before she knew it, she was pregnant. Everything I was telling her not to do, she was doing.

A year after she had the baby, her husband Peter went to jail (he wound up dying in prison some years later), they got divorced, and Carrie went back to California. Carrie got a job as a teller in a bank. She was a real worker, all of my kids are workers, work like hell. That's one good thing they got from me—I got that from my

father. This guy Michael used to come into the bank all the time, and she saw he was a very shy guy. She started talking to him and then dated him. Carrie knew that this is the guy that she really wanted to be with. He didn't drink or smoke, he was just nice. They got married and Carrie had another child.

A few years later, Carrie and my two grandchildren came to visit me for Thanksgiving. She was sick when she came, but I didn't know what she was sick with. I just thought the lupus that she had been diagnosed with was bothering her. But she kept coughing. After Thanksgiving, she goes back to California and then gets very sick with PCP pneumonia. I get a call from Michael and he tells me that Carrie is very sick and he wants me to sit down. I said, "Michael, just fucking tell me what's going on." "Well, Carrie is HIV positive." I said, "Carrie is not HIV positive. Carrie has AIDS. She's past fucking HIV positive." I knew it. I should have known it. I'm a drug counselor, I'm an AIDS counselor. I've been educated and I know all the symptoms. Carrie just couldn't say it. She knew Peter was HIV positive but she thought that God, being that she was a born-again Christian, was going to take care of it. So she never took any medication, she never wanted any medication. That's the choice that some people make. I just wish it wasn't her choice. She believed that prayer and being with God was going to do it for her. For nine years she never told me.

Carrie's on steroids and for the next seven months she has a remarkable recovery. The next year I go out to see her and we have a great Christmas together. The following year she gets very sick again. This time she's dying. For a whole year, I called her every single day whether she could talk or not. She'd put the phone up to her ear and say, "Hi . . . Daddy . . . How, are, you?" I'd say, "How're you doing Carrie? How's things going? I love you. I'm

praying for you. Things are gonna be okay. Keith and Dominick, everybody back here is fine. I spoke to Kayla and Peter before. They're good, everybody's good. They're home praying." She goes, "I'm ... gonna ... be ... okay. Everything is ... gonna be ... fine."

The New York Marathon is coming and I sign up to run. Carrie is very sick at this time and I'm worried about her dying. I'm gonna run this race for her. So I get on the bridge at Staten Island, then I'm running over the Verrazano Bridge when all of a sudden, I couldn't run. I started walking. I couldn't catch my breath. The anxiety was killing me. I was falling apart. I says, "I can't do it. I'm gonna have to stop at the end of the bridge. I'd just finished running twenty miles a day, practicing for this race, but I just can't get it. I just can't get it. There's something I can't get. It ain't coming." I'm just thinking about Carrie, thinking about Carrie, thinking, thinking.

I was running with my friend Mark and I said to him after we finally came off the Verrazano Bridge and were running along Fourth Avenue, "Look, do me a favor. Just go. You run, I'll be okay. If I finish, I finish. If I don't, I'll just meet youse home. I don't know if I'm going to be able to do this." I needed him to run away from me, run so I didn't think that I needed to compete with somebody next to me or worry about him not running the race. Go run your race. And he did that, which was very good for me. I would run for a mile and then stop and walk because I couldn't catch my breath. This never happened to me before. The anxiety attack that I had was overwhelming me because all I kept thinking was, "Carrie is gonna die, Carrie is gonna die." And then I kept thinking, "I'm running this race ... I gotta run this race. I have to finish this race. I'm running this race for Carrie." So the thing that took me all the way through the whole twenty-six miles is that I kept saying to myself, "I can't

quit, I can't quit." If she's in California and she's dying from AIDS and she's not quitting, then I can't quit. I have to finish the race. She's dying there and meanwhile she's calling me up, telling me everything is going to be okay. She's helping friends of mine that are rock stars, writing them letters and they're writing her letters. I got people writing her tons of letters. She has them plastered all over the walls of the hospital. Meanwhile, I know there's no hope for Carrie. I know she's going to die. I just watched twenty-five of my friends die and when you get to this point you're not going to live. You're going to die.

I'm trying to get this in my head, that my daughter is dying and there's nothing I can do about it. I'm powerless. I'm losing my daughter who I love so much. I'm losing her. I gotta start understanding this. Meanwhile I'm going to Marianne Williamson's course of miracles. I'm talking to her. I'm going to her meetings on Wednesday night. I'm going to her and she's saying things to me like, "Even when Carrie goes, she'll always be with you." Just things I needed to hear, to know that I could let her go. I needed to let her go because she was dying, and it's very hard because I really want her and yet I gotta let go of her. So I finished the race. It took me five hours and fifty-three minutes. I get the medal and have it engraved to Carrie. Six months later, Carrie is getting worse. So now I know she's dying and I'm trying to do this shit on the phone. I said to Eileen at work, "I gotta go. I gotta go. This kid's gonna die and I'm not gonna be there. I gotta go out to California." Also I'm talking to my therapist and saying, "I can't do this fucking shit. I can't go out there and watch this kid die. This is my life, this kid. She's so wonderful, she's got these two children. How am I gonna do this?" So he says to me, "Just get on the plane and then get off the plane and do what you need to do."

So I get out there and right away I see this kid and she's talking but she's fucking dying. My friend Linda was there with me and said, "Let's have a big dinner," because we're talking to the doctor and he says it's only a matter of time before Carrie's going to die. Meanwhile I'm handling everything. I call up Keith and Dominick and I send them tickets and say, "Come on out, now. Your sister is dying." So Dominick and Keith come out and stay with me. Keith went home three days before Carrie died because he just couldn't deal with it. Dominick stayed with me.

Linda put on this tremendous dinner, bringing vans with tables and chairs and columns and set up the whole house like a giant French "best cuisine" restaurant like you never saw in your life. You couldn't even give people a tip or nothing like that. They cooked in the kitchen and made steak and shrimp scampi and everything that Carrie liked. She couldn't taste the food. She was all hooked up but we brought her out and put her on a special chair. I have pictures of her from the week before she died. I think I looked at them once. It's hard to look at them today. I can't. I was thinking, let me take the pictures out. No . . . I don't think I'm able to look at them. Sometimes I'm not. Sometimes I can; sometimes I'm all right with it and sometimes I'm just not.

We took films; Michael has movie pictures and I took still shots. Carrie had twenty-five or thirty friends from the church and all her other friends there. A week after that the doctor comes in and tells me she has spinal meningitis and she's gonna be in some pain. I said, "What can we do? I don't want her in pain." Meanwhile she has morphine patches all over the house. And I want to tell you, there's a ton of morphine in this house and I'm a drug addict. And I didn't even think of touching this stuff. All I knew was that I had to be clean. Michelle came out there, my

ex-wife, she was high and I had to tell her, "If you don't straighten up,"—I didn't say it this nice—"you gotta get outta here. You ain't her mother. You ain't nothing. I want you out of here. I got enough to deal with my daughter dying. Don't make me fucking . . . " The thought in my head was, "I'll take you into the fucking desert and kill you." That's how angry I was that somebody would get high and fuck up this whole thing when we're all going through this terrible ordeal, of me losing my daughter.

We now got the kids in the room and the kids are praying. They're holding her hand. "You have to go and say goodbye, because Mommy's going to God." It was hard. It was very hard. But the kids did it. Why would I pull them away from it? Even though Kayla was only six years old, she was so attached to her mother. Everybody she's around she calls "Mother" because she wants a mommy. That's the way she is with women. She will always miss her mother. She'll never forget that first six years of her life that she was with her mother, and that's good.

We let them say goodbye, then the doctor injected her with more morphine. You're allowed to do this to bring on her death a little faster, otherwise she was going to suffer. Me and Michael okayed them to do it. The doctor said, "We're able to do this because we're in your house, not in a hospital." I told my kids, "This is the way you want to die. If I'm dying, take me fucking home. This way you can do whatever you want in your house. You understand? You want to put me to sleep, you want to pull the plug, you do it." My brother died a year later and I watched him die in the hospital, ripping the mask off his face, flipping out in the ER. I told him, "What the fuck is youse doing over here?" I got so crazy with them after watching my daughter just die nice and peaceful. Hit him with some morphine, bring it on baby! Fucking hell, why let him torture himself?

I was running every day and I had Dominick running with me. Keith had gone home, Michelle had stayed. She was with Carrie for a few years when we were married and Carrie was about nine. Michelle did have motherly feelings even though she was active. She was always one for doing the right thing and being there for other people. That's one of her better traits. If she could only learn how to be there for herself it would be different. It's just that she doesn't know how to be there and be fucking conscious unless somebody tells her. Anybody out in California would tell you, even if they didn't know me, I had this face on out there that said, "I'm handling things. If you think you're coming in here to change anything you're in the wrong fucking place. Don't fuck with me. I'm taking care of everything. Just leave it alone. I don't even want to hear your fucking ideas. I know what to do. My daughter is dying. This has to be nice. This has to be calm. This has to be respectful." I was in a trance. If it didn't go the right way, somebody was in trouble. I don't know what kind of trouble they would've been in, but . . . Ultimately I said to Michael, "You're her husband, that's my daughter. Just remember that. So whatever I want, that's what we're going to do. I know you want the best for her but I want better than that." And we did everything together, me and Michael. He's the most wonderful son-in-law you ever wanted to have in your life. He took care of Carrie right to the last day. He was her nurse. When she had the catheter sticking out of her chest, he would give her all the medications. She wanted to die at home and that's what she did, with the kids in the next room. But we didn't let the kids see them wrap up her body and take the body out. We sent them across the street.

Carrie was in her room, sitting in her hospital bed and she had this little angel I had given her, a little tiny angel. She had it in her

hand because I surrounded her with angels all the time. We were talking, then she stopped talking and became incoherent. I said, "She might be sleeping." She was lying in the bed, not talking, and was just staring at us. It was about eight o'clock in the morning and everything was still good. She was breathing and we were watching her stomach and the sheets rise and fall. I said to Dominick, "Let's go do a run. Come'n, let's go. Everything is going to be okay. She'll be all right until we get back."

We did a run, a forty-five minute run. We ran up the road in the desert, all the way to the end. When we were coming back, Dominick, who could run like a little gazelle, ran about a block or two ahead of me down the hill. As I come around the turn, I see everybody out on the lawn. I see Michelle say something to Dominick and then him hug her. I knew Carrie was dead. I knew she was gone. All I kept thinking was that she couldn't die in front of me. I didn't say to myself, "Oh, you bad person for running and leaving her." What I said was I needed to do the run so she could die. She needed me not to be there. I told her in the morning when I was talking to her and holding her hand, "Everything is okay. I'm gonna take care of Kayla and Peter. Things will be all right. You can let go now and you'll be all right." I told her about some of the people she knew who she was going to meet and they were gonna take care of her. We just talked and I said things like that. Then me and Dominick went out on a run.

Afterwards we had to get the kids out of the house. We brought them across the street to somebody else's house and then we called the funeral parlor. We had made the arrangements a week before. Carrie wanted to be cremated so me and Michael went out and found the cemetery. The way they talk to you, "Yeah, the cremation, and then we have to grind up the bone, the urn" . . . they

tell you all this stuff. I was listening to the guy and I said, "Whoa, didn't expect to hear this. I just want her cremated and everything that she's in gets cremated too."

All the clothes that Carrie chose to be dressed in when she died were taken out and hung up. Michelle and a couple of the other ladies dressed her with clean underwear and the clothes that she wanted. She looked like a little country girl in her dress. Everything she wanted she got. Her mother Pat couldn't deal with it, she didn't know what to do. She was sitting out in the next room with her face stuck in a Bible. When Carrie was all dressed, the kids were able to come in and say goodbye. They could see that she was gone.

Me and Michael sat there and we hugged each other. They wrapped Carrie in a sheet, put her on a gurney and rolled her out of the house. We called the hospital to come immediately and take all the stuff out of the house, the hospital bed, all the medications. We emptied out the whole house in two hours. The hospital bed was next to Michael's bed and he slept in the room with her every night.

One day I was there with her alone and she needed to go to the bathroom. I helped her out of bed and into the bathroom and she was in tears, crying. Her stomach was blown up and she didn't make it to the bathroom and she went all over the floor. She told me to go outside, that she'd take care of it. But she couldn't clean it up; everything was all over the floor. It was terrible. That was the most fearful experience I had, taking her to the bathroom. What do I do? What do I do? Do I take her pants off? I don't know what to do. It just happened one of the days that everybody was out of the house.

We went to the funeral parlor and we did the cremation. Afterwards we went to the church, then invited one hundred fifty

people to come back to the house to say goodbye. Again Linda had set up a large buffet with all of this food and fresh flowers. You can't imagine how this place looked, like a palace. It was fit for a king. At the Church we had all of Carrie's stuff that she loved the most. A black biker's bag with spangles all over it that I had made for her, letters and autographed pictures from people she helped and who helped her, pictures of Carrie when she was a little baby. People came into the church and just looked at all the stuff. It was pretty emotional.

People got up and spoke, then I got up and said, "My name is Bob and I'm an addict. I'm in recovery. I know that my daughter would want me to say that because she was very proud of me being in recovery. I'm glad that I'm able to be here for her even on this day." I don't remember what I said, but I know I stood up there and spoke for half an hour, telling people what kind of a person she was, how she held people together in families, the good that she'd done all her life, the life that she led, how we worked on our relationship together, and we went out loving each other. So if there was anybody in this room that has a problem with alcohol and drugs that hasn't got a relationship with their children, I think today would be a good day to start doing something about it. I had people come up to me afterwards, men, and say, "I've never heard anybody speak like that in my life. I have a problem with my kids, and I drink, and I do this, and I think I'm gonna fucking do something about it." I just listened to them and said, "Well, there's no time like the present. You only have a certain amount of time and if you don't have a relationship with your children, why do we have them?"

We went back to the house with all the children and they wrote notes. The neighbors had blown up hundreds of balloons and they were putting the notes on them to send to God for Carrie.

Then they sent the balloons up in the air. I got pictures of balloons going up and Kayla letting them go. It was really very good. It was very nice, very nice.

So at the end of this, after Carrie died, this is what happened. The place fell apart. When I came back from California after my daughter died, I went through some intensive therapy, and then I did some psychodrama weekends with the Caron Institute. I got to do some acting out in heavy duty therapy, killing the guy Peter my son-in-law who gave my daughter the virus and getting out a ton of anger. I was so angry for forty minutes, screaming and yelling at the loss of my daughter, and Peter giving her the virus and wanting to kill him, and my brothers, and everybody that didn't teach me how to read or write. I was just mad at the whole world all over again after thirteen or fourteen years of being clean because I lost my daughter. I did a lot of that kind of work and it was very intense. Even people in my group said to me, "I was actually scared of you. You were so angry I thought you were going to die." I was squeezing a towel like I was choking this guy to death, I wanted to fucking wring his neck out.

I have pictures all over the walls of Carrie. The one thing I didn't do is take things and put them away because she's not away. She's gone but she's not away and I have to understand that. She was so proud, she was so proud of me. She used to say, "My father, my father is a recovering drug addict." She had thirteen years of me and her together, thirteen years of me being clean, and that's what I had to focus on when she died and I had to change my thinking for the children and the grandchildren. "God don't give you everybody for every day."

When I got clean I never thought my daughter was going to die, I thought that I was going to retire and go live with my daughter.

This was my fucking biggest dream, that I was going to live with my daughter in California with her kids and everything was going to be cool. That was going to be my headquarters, my place of residence, and I could see my son Bengie and fly to New York and see Keith and Dom. Now all that is gone. I wonder, what am I going to do when I get older? Are the boys going to say, "Hey Dad, you can live with me?" I say to them, "I live by myself, why don't you call me once in a while?" I get very dramatic about it. "I could be lying dead here for three days and you wouldn't know it."

Family

MY MOTHER loved us, my father loved us. They weren't bad people, but they did bad things, they drank and they drank. They were two uneducated people from another country who came here and tried to live the Christian way. They went by the Catholic Church. I know my mother was Protestant and my father was Catholic. We were brought up Catholic, but my mother fought about that all the time. My mother would sit in the house and she'd do all this cooking, she'd drink, she'd cook, she'd drink. She wasn't a mean person. She might have been mean to my father because that's the way I look at it. She was mean to him later on when he got sick.

My father got sick in my late twenties and he died when I was thirty-three. By this time I was a blooming heroin addict. He had gotten cancer and had to retire. He would come home from the hospital, get strokes, and have to go back. He was still drinking a little bit at this time, not too much. It was pretty sad to watch him

drink at all. Then he went into a hospital for terminally ill people. He eventually died at St. Rose's Catholic hospital for terminally ill patients on the East Side of Manhattan. The nuns there were nurses and they actually predicted the time that he'd die. They said, "Oh, you got about twenty more minutes or so." It's kind of weird how they know because they see so many people die. I was over at the hospital the night he died. I really forget who else was there, maybe one or two of my sisters and my brother Billy. My head was not so clear at the time. I was a dope fiend, out there drugging, making money, doing all this crazy shit. I was married to Michelle. I remember getting high in the bathroom at the funeral parlor, shooting dope.

My mother was alive up until my second year clean. The first year she came to my anniversary. She thought it was a big deal that I was clean. My mother was in a home at this time, the same home she worked in for years only now they were taking care of her instead of her taking care of them. I brought her in her wheelchair.

One of the things about mothers is no matter what their children do, they don't think it's enough. I had grown a beard for a while and I said to her, "Well what do you think, Ma?" She said, "What do I think of the beard?" "No," I said. "What do you think about me being clean and sober, not using drugs no more, and I visit you, and I'm okay, and I don't drink anymore." "Yeah," she goes, "That's all good, but why don't you shave that beard off?" Like you can never do enough. But did she understand the extent of what I was doing at that particular time in my life? No. She didn't know that I was a hardcore heroin addict. She didn't know that I'd made millions of dollars, that I'd been involved in big criminal drug dealings all over the country. She didn't know that. So for me it was a big deal that I was clean and not using. It was a very important time in my life.

We were eight, five brothers and three sisters. Randall, Billy, Betty, Sal, Margie, Frankie, me, and Lillian, in that order. My brothers Randall and Billy were the first to leave the house. Randall, the oldest, went into the Navy. He was an oddball, a very funny guy who went to the Korean War. When he came home, he got married to Lillian. I was eleven years old when he got married. I got the picture of me in a tuxedo. She was a big drinker. He was off and on with her for thirty years. He stopped drinking and became clean and sober for twenty-seven years before he died. Randall was the nuttiest guy I ever met. He was just a fucking crazy little guy. He stuttered for as long as I can remember.

Billy got married to Lucille and moved out to Long Island never to return to Brooklyn. Every once in a while, because I was getting into trouble, my mother would ask him to come and talk to me. When I think of him today, as a brother or about our relationship, there's none. He was gone. He used to own clubs and he was in construction, he still is today. He was a big contractor out on Long Island, but he got involved in a lot of messes too. He was a real mild-mannered guy. I used to think he looked like Chuck Connors from *The Rifleman*. He's the only one of my brothers that was left-handed, six-foot-two, with jet-black hair. We would joke around and say he was from the milkman, because there is nobody in the family who looks like that. He was pretty cool.

There were times when I was in a lot of trouble. Billy owned these bungalows and a motel and owned a resort with another guy. After his first wife Lucille died, he was a big playboy. From then on he was in a lot of shady stuff. He owned this club where he had these girl bands. If I got into a lot of trouble, he would tell me to come up there and hide out for a week or two with him. Unbeknownst to him, I'd be sick as a fucking dog from heroin

withdrawal because I had started using. He didn't know to what extent I was on drugs. He was good, he didn't criticize me so much and he bailed me out of jail. A couple of times he said, "Leave him in jail," my brother used to say that. But if I look back on it today, I say to myself, "I would leave your ass in jail." Because I just kept getting into trouble and I was always getting bailed out. That was my older brother, Billy.

My brother Frank, who's a big Wall Street guy, lives in Staten Island. He's been in a relationship now for the last four or five years. He always knew where my life was, I did things for him too when I was paid to do it with different people on Wall Street. He asked me and I did jobs for them and they paid me. And basically the jobs were all illegal jobs, maybe somebody got a girlfriend that they wanted to be threatened, to stay away or something like that. Like some guy has a mistress and all of a sudden he wants to drop her and she doesn't want to leave the guy, she wants to haunt them, so like my job would be to go up to her and say, "That's gonna stop, we know that right? I mean you're not gonna go around there no more, is that correct?" We would say things that would tell her that she would be hurt if she didn't stop and usually they had the keys to the apartment where the girl lived. And when she was out I would go up to the apartment, take her jewelry and maybe slice up all her two thousand dollar gowns and coats and stuff like that to let her know that we weren't kidding around. Wow, what a life! It was like anything for prestige. There wasn't a job that I couldn't handle or get somebody to do. I was like a fixit guy. The funny part about it is that when I'm working in the rehab today being a drug counselor, that's what I do. They call me a fixit guy because I'm a problem solver.

Sal was five years older than me and a year younger than Betty. He lived in the house on Twentieth Street where I was born and

he died there. He never left. That ended a fifty-five-year career of the Powers family on that block, Twentieth Street and Eighth Avenue. Fifty-five years we were there.

Sal worked in the pearl factory with the mother-of-pearl, up the block there on Twentieth Street all his life. He worked for practically nothing, never knew how to read or write. He always had girlfriends, never nobody steady, but he would see different women here and there. His thing was drinking and partying and coming home. Him and my mother were two alcoholic buddies. Until my mother went in the home, one fed off the other one's disease, my mother calling me up all hours of the night to come down and get him out of the house. Then I go down and have a couple of fist-fights with him and beat the shit out of him. That's what we did; it was terrible. I took care of Sal for two years before he died.

My brother Sal died a year after my daughter died. I did a lot for him—it's that brother instinct —no matter what goes on you help them out. Even though he was very selfish, he gave all of his nieces and nephews presents, which was really incredible. He never was married and he never had children. I found out he tried to do a little incest thing with my daughter. I don't know what happened to other nieces or nephews who went to the house, but I do know he got fresh with my daughter Carrie because she told me all about it. I was in recovery at the time and I said, "If you want to confront him, I'll do that with you." She was living in California at the time and said, "No, he's not well." I said, "Whenever you want to, I'll work through that with you, to tell him that you didn't like what he did or what he asked you to do while you were living there." It never came about, and I just let it go. But I know my brother Sal was a dirty old man. He had girls in the house, neighbors and shit. His thing was pornography. But I still helped

him the last few years of his life. Did I fight and argue with him? Yeah, a lot of the time, even when he was dying. I told him a few times, "You want to lie here and die? That's what's going to happen if you don't do what the doctors tell you." But people don't always have the courage to do that.

Until the day he died of emphysema, Sal was an alcoholic and his body was falling apart. He had ten years of recovery and then started drinking again. I used to catch him with cigarettes, even smoking while on the machines. That's a suicide mission. Sal never knew how to read or write, he was a total illiterate, even worse than I was. Sal was sixty when he died. He had nobody. In the end I watched him in the ICU at the hospital, trying to pull the mask off his face—they couldn't give him any morphine.

Watching my brother die like that was a heavy thing for me, but I knew that he didn't have to suffer anymore, he didn't have to get up and pay the rent, he didn't have to worry about the phone bill or April 15th. All that fucking stuff is gone. In my head I said, wherever he goes, he goes, and if he meets Carrie, maybe they can have a talk about his behavior.

My sisters were on their own when they were eighteen, nineteen, twenty years old. I was still a kid. Betty, my oldest sister, is six years older than me, so when I was fifteen she was twenty-one. She was hanging out with the bikers and she had a kid by the time she was twenty. Betty married this guy Tony, and she's still with him. They stayed close around my mother, which was a big burden for them, but she was the oldest sister. Today she has three daughters and a son.

I don't get along with Betty at all and I don't want nothing to do with her. I just have this terrible resentment about her. She was greedy, very bloodthirsty. I used to leave a lot of money and things over at her house when I went to jail, but still today I've never gotten

anything back. A lot of my friends were dope fiends and they went
to her to sell gold and stuff—she was like a fence. Everything with
her was illegal. She was a real manipulative conniver, even when my
brother Sal died. Me and Margie were wondering how we were gonna
bury him. Right up to the last day we were in the funeral parlor mak-
ing plans how we were gonna chip in to buy a casket. The next day
we found out Betty had his insurance policy. She thought somehow
or another she was gonna keep all the insurance money for herself.
She's fucking ruthless. I really dislike her for that.

When I went to my niece's wedding, they asked the family to
get up and dance. Betty didn't come with anybody and I wasn't
with anybody either, so Betty said to me, "Come on, will you
dance with me?" I really wanted to say no, but I didn't. I stood up
and I danced with her even though I got this terrible resentment
about my stuff, and she knows it. I should tell her I want my stuff
back, but it would be useless and she would deny everything.

I had a big antique knife collection that Betty gave to her kids.
My niece Nancy has some of it and she knows that it's mine. I
asked her for it and she's supposed to mail it back to me but she
hasn't done that yet. Yeah, sure. She's gonna mail it to me, but she
can't do it right now cause she's an addict. Her mother denies all
that. Meanwhile I put her in rehabs and detoxes.

It's better for me to stay out of it than to argue with my sister
about something that she has of mine from twenty-five years ago.
I'm doing fine without it. I'm doing fine without her. It's amazing.
I grew up thinking I'd always need my family to help me because
I felt so bad about myself. I didn't think I'd be able to support
myself, but today I support six grandchildren, not financially,
but I'm here for them. I go to California, I come back, I fly out for
Thanksgiving dinner. I'm here for them. I never had that and I

know how important it is for me to be present, just to say, "Hello, how you doing, do you need me, no, all right, see ya later." That's what they need, they need to know that I'm present.

Then there's Margie. Margie is the sister that I talk to the most. She's the nice person, everything is nicey nice. She might tell you how bad I was, but she'll paint it in a different color. She'll say that's the way it is, that's the way it was and they did the best they could, and they did. I believe that too. But there's no pain in it for her. There's no hurt or anything. She's not an alcoholic but she drank a little bit. I can't call anybody an alcoholic except for the ones that are in AA. Margie is the biggest caretaker in the whole bunch of us. She takes care of all the family, actually she keeps everybody talking to each other.

Pat

PROBABLY IF my first wife Pat was less dysfunctional and wasn't an abused kid herself, she would have made a terrific wife and mother. She's a born-again Christian today living in California. She takes care of her mother. Her life has changed a lot. She met a couple of other "Bob"s after me and she had a few other husbands, but it didn't really work out. We were two lost kids when we were together at fifteen or sixteen years old.

There were times I almost killed Pat. We had a couple of big fights when she was seeing some guy and I caught her. She was destroying my ego and my image. It was terrible. So much hate came about from her doing that. But I wasn't the best of guys; I was mean, I hit her, I was an abuser. I choked her one day until she was blue and it took two cops to pull me off her. I threatened to kill her a million times so why shouldn't she be mean to me? The pain turned to anger. I needed her to stop doing what she was

doing so my pain would go away. She did what she did because she didn't want to be with me, because of who I was.

She wrote me a letter when I was nine months clean. I still got that letter, telling me that I was the only guy she ever really loved, and she wishes it was different. So what she was saying was that she also wasn't able to do the right thing at that time. She was fucked up herself, damaged. But the way she hurt me the most was to be with another man. That was the ultimate damage that she could do to me, living in my neighborhood and everybody finding out that Pat was with another man was the ultimate humiliation. I felt like I could never get rid of that shame and that guilt, and I kept it. I just couldn't see her.

Michelle

MY FATHER-IN-LAW was the sweetest man I've ever met in my life. The truth is, I never got along with my mother-in-law. But when we moved to our own house, which her parents bought us, I only can look at how nice her mother and father were. They were trying to make it work for us. They were giving us a head start with the house and the cars, buying us all this shit. They were very enabling, but I don't think that was the sole purpose. It was to do something good for their kids and that also the family doesn't want to see two people fucked up. They want to make it look like everybody is doing well.

Michelle was a girl that was very uncontrollable even when she was seventeen. She was a beautiful, tough tomboy. We would stay out all night, sneaking in and out of her house. We'd have to go home at a certain time, and then she would sneak back out and do speed. We were doing all this when she was just a kid. Her mother knew that she was using, but she still blames me

for everything that went on with Michelle, from Michelle's drug addiction to her later having AIDS and dying in a car accident.

Sally

SALLY HAD another son, Richie, who was a little pyromaniac. He used to light fires and he'd get this blaze going in the bedroom and I'd have to stop him. Richie died in an accident down in the subway tunnels. He was hit by the F train while drawing graffiti. He got killed at seventeen years old. If there was nothing else I could do to make amends, it was that I went to the church for the funeral. I stood in the back and stayed on the side where I wasn't so visible.

Later I met her older son Leo on the train. He kept in touch with Carrie and we made some kind of amends, me and this kid. As much as he and my daughter liked each other, I think it was because they shared each other's pain. Carrie would tell Leo, "My father, look at my father." And Leo would say, "Look at my mother." And both of them gained strength out of that to carry on with their lives. Leo today is a businessman. He's got some real estate and he's a good kid. He has a wife and a family. I hope to God he's still like that and he got himself out of being a wise guy or a tough guy or anything like that. I hope he's legitimate and can show his kids a different way of living.

Sue

WHEN I married my third wife Sue in recovery, we had a dog, Long-fire, with three legs. We got him when he was a year old and I taught him all kinds of tricks. That was the only way I could make up for killing my old dog. She knew what I did. She knew. One time I told her

and she says, "Never tell me this story again. I don't ever want to hear you say it," because she's a real animal lover. And I never did.

My Kids

MY KIDS lived in one place and I was living in another. It was very sad. The two oldest were living with somebody else at the time, before California. My son was living with two people who were both drug addicts and he was dealing drugs for them. I wasn't paying attention to him or anything like that. I didn't pay attention to him for a long time. I would criticize him, I would be very demanding and very controlling, very angry and very sadistic with him. "Fucking better do this. I'll break your face you bastard. Who do you think you're talking to?" I would talk to him like that—very vindictive. I think a lot of that is why he really came to not love me. But I know deep down my son loves me; I spoke to him the other night. He works six days a week. He works in construction out in California and has two children. His life is okay. He knows what I do. He's come to some meetings with me. He just can't get over the past. There's times when he says, "Hey, I remember what you did to me. I remember you being like Hitler when I came home at night. Making me scrub the floors in the middle of the night. Ever tell anybody about that?" And I say, "Yeah, I do. But that's fifteen years ago." And for the last fifteen years I've been trying to teach him what I'm doing, hoping he will get it. I really feel bad about his past life.

Carrie

CARRIE LIVED with me in the house for a while then moved around the corner to her girlfriend's house. She was getting to be sixteen at the time and was hanging out with the boys. I remember

her coming up to me and telling me she had sex with this kid Mikey who wound up a year or two later getting killed in a motorcycle accident. That was pretty sad. He was a nice kid. I liked him a lot.

Just before my daughter died, I started developing the relationship I always wanted with her. We could talk about everything. Me and Carrie started working on each other and we had some tough times. We went through lots of rough times. She went through all the blaming. "Look what you did to me, look what you did." And I said, "What about me? I lived the life. I was there. I'm sorry. Everything after I'm sorry would just be bullshit. I can't change what happened but I can make things better today for you. We can work on having a relationship. We'll work on all the bad stuff that I've done—the dope, the bodies, the this, the that." Carrie saw it all and so did my son Robert. Not only saw it all, but I blame myself a little bit for his drug dealing and his drug using. I still have guilt but there's not too much that I can do about it. I'm totally powerless over it. I have to really learn to let go. Once I learn to let go of the guilt about my children then we can have a life together. I've been married three times, not that it was all bad. Carrie became the one who got into the recovery thing so we had a lot to share with each other. My grandson Peter was nine when Carrie got AIDS. When she died part of my world disappeared. Carrie was like my sister Margie—she kept the family talking. Without Carrie, my whole family fell apart.

Grandchildren

I'M A PRETTY rough and tumble grandfather. Some people say they think I'm the coolest grandfather that's ever walked this earth. "Bob, look at you! You got tattoos, you got long hair, you love them, you talk to them, you understand them, you're cool, you discipline them, you get mad, you don't take no shit from

them and yet you love them and they love you. How many kids go around with a grandfather like you?" Now, that's other people looking at me. I wish I saw myself like that because sometimes when I have to talk to my grandson Peter and discipline him, I get a bit nervous. I feel that he's not going to love me. But he does; he really does love me. He likes to be disciplined. He does a lot of things that I used to do when I was a kid to get attention. For instance, one time before my daughter died when Peter was seven or eight, we were playing baseball in the California desert and he had four or five of his friends with him. We were all playing. I was doing the pitching, they were doing the hitting and we were playing ten hits each. Peter gets up and has ten hits, another kid gets up and he gets ten hits, then Peter wanted to get up again. I said, "No, it's his turn." But Peter says, "It's my ball." I said, "No, it's not your ball. We're playing with the ball, now it's my ball. Grandpa has the ball. So we're playing ball. Do you want to play with us?" He says, "Yeah, but I want to get up again." I says, "Well, Peter, you don't really have to play with us. You can sit on the side but we're going to play ball. You don't have to play with us if you don't want to." I watched this little kid walk over, sit on a rock and look at us playing ball, and I saw me. I saw me. But the thing that Peter did differently was, within ten minutes Peter got up and said, "Okay, I'll play the field." He got up and went to the outfield. I would have never gotten up. In my head, I'd go, "Fuck you, fuck the game. If I ain't getting my way, that's it. I'm out of here." And then you were my enemy forever. But Peter didn't do that. He got up, got his glove, then went back out to the field behind me and started catching some of the balls that the other kids played. So, did it bother me to do that to him? Sure it did! It bothers me to discipline.

Peter is twelve years old, he's in the Yankee Stadium with me—I brought him in from California for his birthday. He was having

problems because he just found out through an error in school
with names that his father really wasn't his father. He just lost his
mother the year before from AIDS and now we had to tell him
that his real father died of AIDS too. But I don't think that was the
hardest part to do. The hardest part was when I brought him here,
knowing all this was going on and still having to discipline him. It's
so hard to say, "Well, this is what we're going to do, you gotta get up,
let's go, get your clothes on, we're getting ready, let's go."

We had great seats over the first base line on middle deck, great
seats. We're watching the Yankees play. There were a whole bunch
of us there: Keith, Dominick, his girlfriend, my friend Errol, and his
son Jakey. Peter had gotten some ice cream and I said to him, "Give
me a little bit of your ice cream," and he wouldn't give me none. I
said, "All right, that's not nice. Why don't you share some?" He says,
"No, it's my ice cream." He was sitting in front of me and I thought
the way he spoke to me was disrespectful. So I leaned down real
close to him, bent over the bench and got almost cheek-to-cheek
with him so he could hear what I'm saying. I tapped him in the face
with my two fingers and said, "Don't you ever talk to me like that
again. I want an apology right now." He says, "I'm sorry." I says,
"Never again, or these two fingers will turn into my whole hand."
It's like the only way I know how to do it.

If my grandchildren ever get to read this or hear this, they're
going to think that I made up this story because they know me as a
loving, caring grandfather that sends them gifts on their birthdays,
mails them candy on Halloween. Because I don't want them to
forget me like I was forgotten in my family. What gifts? What Hal-
loween candy? Nobody did that kind of shit. They didn't know you
were there if they did bump into you. If you didn't yell or make a
commotion in our house, they didn't know you were there. People

would walk in, sit down, eat whatever they had in their hand and never offer you a fucking lick or a piece, even though I was a little kid. They'd eat ice cream right in front of you and then look at the big-ass black-and-white TV that we had and never say, "Here kid brother, I'll give you some." It just wasn't like that. That's just the way it was and even though my family and I get along now, when I think of the way it was, it still makes me very angry.

Bengie (now Bob) and his sons, 2009
Clockwise from far left: Dominick, Bob, Jr., Keith, Bob

CHAPTER SEVENTEEN

Sobriety

YOU NEVER can see yourself. When a window dresser is doing a window, he knocks on the window to the people outside and he looks at them and he goes, "How does it look?" Because he's so close to it he can't see it. I didn't go to Vietnam, but I was in a fucking bigger war and mine didn't end in the seventies. You're in a war against the cops, against the drug dealers, against yourself. It's all against yourself. You're fighting a war and you don't know who your enemy is. You're fighting a war and you're killing your enemy. The war takes your best friends and you think your best friends are after you. Your best friends! Once I caught the habit, it was all over for the next twenty years. I started heroin when I was twenty-two years old and I got clean when I was forty. It was terrible. The heroin took all my dignity and my self-respect away. When you shoot heroin, when Eddie gave me the heroin that night and I was throwing up all the way from Avenue C down to Hoyt and Degraw,

it didn't matter. That night it just seemed that everything was so good. And I did it again and again. You don't get a habit right away.

If I was to go out to get heroin and I was to throw up from it, I'd know I had good stuff. That's the sign of really good dope, addicts think. You eventually stop throwing up, and when you stop throwing up you get this tremendous high, a euphoria. What goes up comes down, when euphoria wears off and reality is in front of you. It's hard to stay up all the time. What happens with heroin is that once you get a habit your body needs it, like I did heroin for a year and a half or almost two, before I fucking found out I had a habit. How I found out I had a habit is that I got locked up one night. I went into jail and was in there thirty, forty hours, and I started crawling the fucking walls. I said, "Oh shit, I really am an addict." Until then I thought I could stop anytime.

When you're in a withdrawal every joint in your body starts aching: your knees, your arms, your back, your neck, your spine. Everything gets so uncomfortable that you can't find a place. You could lay on cold floors or marble floors where it feels good, you get up, you lie here, you turn, you lie on your back, you lie on your stomach, you lie on a window, you lie on a fucking blanket and you lie in all different places. I was in jail with a seventy-something-year-old guy, an old black guy. They put us in a cell with no sink and just a bucket of water. We drank out of a stainless steel bucket, that was our water. All I did was throw up near the bowl. I kept telling my partners, "You fucking gotta get me out of this joint." When they finally got me out on $10,000 bail, I ran right to my apartment on Dayhill Road and I ripped the fucking ceiling out. They were all looking at me, all my friends. "Just shut up." I opened up the box, the toolbox with the key, took out a big fucking package of dope. I mixed it up and I shot it. As soon as I shot the dope and after I got high, I just looked at everybody

and said, "All right. Where are we at? What's happening? What are we gonna do now? Who ratted us out? What happened here? How did I get locked up?" I was able to conduct business.

It is true what they say about heroin addicts. It has a different stigma than people that do coke or crack or that drink. A lot of cool people did a lot of heroin, but once I got around other people I found out how much heroin wasn't accepted. The heroin addict is at the bottom of the list because people think you're a lowlife. I personally think the crack addict or the cocaine addict is more low-life than anybody, but the heroin addicts are a very unique bunch of people. They have a lot of intelligence, they can be super cool, they talk a lot of jazz, they're very very smart people. When we deal with them in the field of addiction, they're in a class of their own. It's been like that for one hundred years if you read back on morphine, heroin, jazz musicians, and the elite. It's kind of a cool high, detached. If you're not totally out of it, you seem to have this terminal hipness about you. That's a good word, terminal hipness.

When you come into a rehab and there's three or four heroin addicts compared to ten crack addicts or cocaine addicts, you'll find the heroin addicts always drawn towards each other. They'll always be talking to each other because they think they are better than others. They'll whisper, "They're crack addicts, crackheads, cokeheads, alcoholics." Speaking clearly they'll say, "We're heroin addicts." They think they're very cool. They are very cool. They're very sensitive and nice. This is what I always tell people in the rehab where I work. The majority of heroin addicts are angry and resentful, but when they clean up, you have the good guy. I've seen the meanest women and men turn into angels just because they stopped using. Heroin is like a fucking demon.

From the time I was sixteen years old hanging out in Peter's cellar, I always thought heroin addicts seemed to have a cool thing

about them. It was the sunglasses. They always had on sunglasses, and a toothpick in their mouth. They were always drinking a container of coffee with a newspaper folded under their arm like they were looking for a job, a job that never came about. They had all these things circled in the newspaper and I believed the newspaper was under their arm for about ten years. It's 1955 and the thing's been under there since 1945, the same paper. They were always reading. If it wasn't books or magazines, it was a newspaper. Hanging out, bending over, halfway down, nodding out like they're in Oz, dribbling, waking up, reading. They had a lot of answers for things. Lots of them went to music and jazz concerts.

It's a crazy thing to say but drugs saved my life. Isn't that wild? They saved me from dying. They saved me from going to the electric chair for killing somebody. Drugs gave me another focus. My focus was to get more dope. The focus wasn't on killing anybody. The focus wasn't on fighting. The focus was just on how could I get more drugs without getting caught so I wouldn't go to jail. The focus as far as I was concerned was, "What can I do to make more money to get more drugs?"

Being on the methadone program was the worst time in my life. I was on it for twelve years; it was a ball and chain. I can't see how anybody could say that methadone is good for you or that you could function. I never functioned on it as a steam-fitter, I never functioned on any job being on the methadone program. It's crazy saying that people could work a normal job on 100 mg of methadone. That's like me saying I could work shooting a bundle of dope. Yeah, you could be a brain surgeon, but I'd hate to be the brain that's fucking getting worked on. There has to be a different way; I don't believe in the methadone program. People are just making money off of the programs. They're all privately owned and subsidized by the city and

the state and we pay for them. I think they're all crooks and liars and I know this from being on it for twelve years.

I'm sorry to say that still today I have a big problem with cops. I remember being beaten half to death one night on the parkside; I was found by the cops and they took me home. They didn't take me to a hospital just because of who I was. They know you're from the neighborhood and they think, fuck you, die you little bastard. The cops thought like that because we gave them a lot of problems and they gave us a lot of problems. It was us against them, that's just the way it was.

It's 1959 and you look around and you say, "Where's the cops?" There were twenty thousand then, now there's forty thousand, and you still look around and say, "Where's the cops?" Do they all get paid to stay home or does it just seem like that? When they have to be in place for the mayor or a union rally, they're out in fucking force. If somebody's gonna protest or march, there's a million cops on the scene, or if they're gonna have this Million Man March then there's seventy thousand cops with fucking armor on. Sounds like I got a resentment against them. Well, you get beat up as many times as I did by the cops, taken for as many rides from the time you're twelve years old . . .

I think back about how the alcohol and drugs got me to be so mean. It's like I don't even think it was me that I'm talking about. I'm a totally different and changed person. It's like the guy I'm talking about is a guy that I once knew. He doesn't really exist anymore. This guy is dead and I can tell you all about him because I hung out with him, I was very close to him. But I'm not that guy.

The other night this guy comes up to me and he says, "Hey, Bengie! How you doing? Boy, you look terrific!" I talked to the guy for fifteen minutes and he says, "I still go to the Greenwood Group; I'm chairing the meeting down there." I said, "Yeah, that's very good," and blah, blah, blah. When he left I leaned over to my friend Harry

and I says, "I don't even know his name. I think it could be Richie, but I'm not sure." I wish when people come up to me they'd say, "I'm Charlie" or "I'm Richie." I should put a sign on me saying, "I was in a black-out for twenty years. What's your name?"

When I found AA and NA I learned you don't have to suffer. Hundreds of thousands of people take themselves on this journey of pain and suffering only because they don't have a clue of who they are. The drugs make them somebody else and keeps them from stopping. Some people do it until they die. You really have to believe that this is a gift from God, if there is a God. Why am I getting this gift and why is the guy who goes to therapy for years still using? Sometimes I wonder why a therapist even keeps doing therapy with them. Don't they know that it's impossible to talk to somebody who is using? The best place to talk to somebody is in detox where they get clean first. They have to be clean for at least two months so that whatever you're telling them gets in their head. They gotta realize they have a choice in the matter—you can get high, or you can stay on this path—that's the thing I teach in the rehab.

All my life I thought I didn't have a choice. By the time they leave the rehab in twenty-eight days, I pound it into their head that they have a choice. You can't blame your mother, or that you're not getting laid enough, or that you're the poor black guy . . . Shooting dope ain't going to get you from homelessness to a Park Avenue apartment. But not shooting dope is going to get you a job, so you can get an apartment, so that one day you can work your way to Park Avenue, if you want to. It's not a big deal to me. But when you leave you should know that you have a choice. If you shoot dope, it's because you do not want to live in the here and now. You don't want to go through the pain of doing things as people do, as normal productive members of society.

Responsibility. You don't want to pay rent. You want somebody to pay your phone, your cable. When you get clean all that

responsibility goes on you. Nobody who runs around getting the money to get dope worries about the rent. Nobody says, "Oh they're going to shut my cable off next week." They don't care. They'll get rid of cable, they'll sell the TV. It took me about a year going to meetings to find out that I really surrendered. What they were talking about was abstinence from all drugs. I was abstinent, but there was still a part of me that wanted to get high, even after I got clean. But I was having fun, I sort of prolonged it, and that's what you do until a bulb pops up in your head that says you don't have to use. It's amazing.

It took a few years for it to really hit me that what we were talking about is that I can't use any chemical safely, no more. It will actually start my engine all over again, the old way of thinking. If I use a mood-altering chemical, I will start thinking automatically about how to get more and more, and more and more. There's no end until my money's gone, everybody's money is gone who's around me, doors are locked again, and I'm in the park again, sitting with the bags on the parkside saying, "What happened?" I was saying those words with the shopping bag in my hand, "What happened?" How did I get from there to here? With kids and wives and family and drugs and millions of dollars? How does it happen that I don't have enough to get a packet of Hostess cupcakes?

I don't ever want to say to myself that I can't use, because I can, because I have a choice. As my life got better in the last years, I've developed more things that are in my life to keep me from using: my friends, my grandchildren, my family, the people I work with. Why would I want to destroy all of those relationships, all of them good things that you've put together, to get high? I always say that no matter what happens to me—and I said this before my daughter died—no matter what happens to me, I'll never use. I'll go through it, the pain, because that's what you need to do. And like my friend

Richie said to me one day when his daughter was murdered and I asked him how he was doing, he said, "There isn't enough dope in the world to take this pain away." And I know, no matter what happens to me, the dope is only for a few minutes and then the pain comes back. So why not deal with it right then and there? And that's what I did when I was with my daughter.

When I came into the "program" and I went to my first meeting, one of the first things was a step meeting, and we talked about step nine. It's about making amends to people. I didn't really understand all that stuff, but what they were talking about was that in the eighth step I'd have to make a list of all the people I've hurt and then in the ninth step I was going to have to go and confront these people and say I was sorry. I said, "Holy shit. I can't believe there's a fucking program like this. How can I ever possibly do this?" I mean, I gotta have ten or twenty people around me to think about how many people I've harmed and hurt and did this and that to. But the bottom line is that you stay clean. You make a list and the rest gets done by just getting clean. I make amends today by helping people. When it's possible for me to help somebody that I've harmed years ago, and I see them again, I will. I don't go around telling everybody that I'm sorry. I'm not about to do that. My amends come from being in my neighborhood all my life and mostly that I'm willing to help anybody—race, creed, color, religion, I don't care who it is.

That's what I do today to relieve some of my guilt from the past. Because my past is bad as far as I'm concerned, because I lived it. I mean, it's my past, it's my way of living. It's sad and it really is very painful to me sometimes. It's very painful when I think about the kids. When I run on the boardwalk, I think of the past. I run and I think and I think and I think, and things pop into my head about who I harmed here, and who I harmed there. And then I'll think some good thoughts about my grandchildren, about what I can do for them, and I just

hope and pray they don't ever get into what I was into, the way I lived. There's a lot of people that can go out there and self-destruct in no time at all. I hope this never happens to any of my children or grandchildren and that they try to understand they should be doing something good for themselves instead of living like I lived.

When I first got clean, I shot a deer after ninety days. I killed the animal and I went and told people that I shot Bambi. Some people said, "That wasn't really funny." When I went home I saw it over and over in my head. I did so many things in my life that could keep me awake at night. Now I do this? I ain't doing this fucking shit no more. So I went and tore up my hunting license. Now I go in the woods and see them deer with their babies—that is so cool. They see you but they don't run away. It's like they know you aren't going to hurt them. It's like God working, even though I have a very hard time believing in God. I have a hard time believing in that, but I don't have a hard time believing what I've been through. This God got me where I am today. That's a great awakening—that you're not in control of anything. What I did do was take all the necessary steps and put years of work into it.

I can remember as a kid sitting on the corner saying, wow, it's gonna be 1975 someday. Spaceships will be in the street and fucking cars are gonna be floating in the air. I used to dream like that from seeing these space movies. I couldn't imagine what the year 2012 would be like, never thinking that I'd be here for the year 2012—with twenty-eight years clean and seven grandchildren.

Now in 2012, at the age of sixty-nine, my focus is on my three sons and my seven grandchildren. To be with them, to take them on vacations and to be a part of their lives and to continue to help them in their struggles. Most of all, I am grateful to the friends I've had for the past twenty-eight years in Narcotics Anonymous who helped me and showed me how to live.

Acknowledgments

Sincere thanks to:

Bruce Davidson, who encouraged me to write about "the gang" for his own book, which inspired me to continue writing the rest of Bobby's story.

Dan Simon and Gerhard Steidl for believing in this project.

Bonnie Kassel, who with her intelligence and patience has helped me see this book through to the end.

Amy Robbins for her expertise and literary knowledge.

Gabe Espinal for helping to finalize the book.

Julia Griner, who was there at the start.

Amina Lakhaney, who has been good enough to respond to my occasional pleas for help.

Dr. Carol Fink, a college cohort who was generous with her razor-sharp mind.

Joe Lelyveld, a dear friend who was kind enough to read the manuscript and share his insights.

Martin Garbus, an attorney and friend who has led me through safely.

My friends and family who haven't abandoned me for my lack of attention during this long episode.

—Emily Haas Davidson

Never in my wildest dreams did I ever think I would be alive today, let alone have a book written about me. Throughout my life there have been people that have helped me make this all possible. I would like to take this opportunity to thank them.

My mom and dad
Francis and Mary Powers

My brothers and sisters
Frank, William, Randall, Sylvester,
Elizabeth, Lillian, and Margaret

My children
Robert, Carrie, Keith, and Dominick

My grandchildren
Peter, Kayla, Heather, Dylan,
Dominick, Ethan, and Michele

Narcotics Anonymous
My closest friends and support group

Bruce and Emily Haas Davidson

Robert and Kim Corrado of Interline Housing

Coworkers at Cornerstone Medical Arts

Seward Park Library Centers for Reading and Writing

—Bob Powers